D1128656

DEDICATION
THIS BOOK IS DEDICATED TO NETHANEL AND DINA KALUJNY.

Copyright © 1994 by Todtri Productions Limited. All rights reserved.

No part of this publication may be reproduced, stored in a
retrieval system or transmitted in any form by any means
electronic, mechanical, photocopying or otherwise, without
first obtaining written permission of the copyright owner.

This edition published in 1994 by SMITHMARK Publishers Inc.,
16 East 32nd Street, New York, NY 10016

SMITHMARK books are available for bulk purchase for sales promotion and premium use.
For details write or call the manager of special sales,
SMITHMARK Publishers Inc.,
16 East 32nd Street, New York, NY 10016; (212) 532-6600.

This book was designed and produced by
Todtri Productions Limited
P.O. Box 20058
New York, NY 10023-1482

Printed and Bound in Singapore

10 9 8 7 6 5 4 3 2 1

Library of Congress Catalog Card Number 94-66828

ISBN 0-8317-5778-7

Author: Henri Lallemand

Producer: Robert M. Tod
Book Designer: Mark Weinberg
Production Coordinator: Heather Weigel
Photo Editor: Ede Rothaus
Editors: Mary Forsell, Joanna Wissinger, & Don Kennison
DTP Associates: Jackie Skroczky, Adam Yellin
Typesetting: Mark Weinberg Design, NYC

CONTENTS

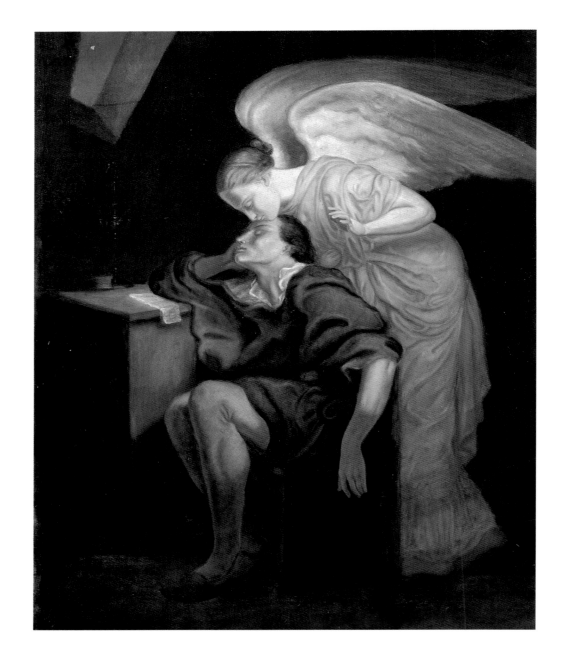

The Poet's Dream

1859–1860; *oil on canvas;* 32 1/4 x 26 in. (82 x 66 cm.). Paris, Musée d'Orsay.

From November 1858, after his baccalaureate, Cézanne began attending the free drawing school in Aix which offered classes under its director Joseph Gibert, while at the same time studying law at the local university according to his father's wishes. The present work shows the influence of academic painters. The subject was probably intended as an homage to his friend, the writer Émile Zola, who at the time was living in Paris.

INTRODUCTION

Throughout his life, the landscape around Paul Cézanne's hometown of Aix-en-Provence in the south of France exercised a major influence upon him as an artist. He returned to the same sites over and over again, trying to depict on canvas his vision of nature—most particularly that of the Mont Sainte-Victoire, which rises to its impressive peak not far from the province of his birth.

Cézanne's family came originally from the small, mountainous town of Cesena, now in West Piedmont, and they might have been of Italian origin although families of French stock populated the region as well. In the seventeenth century members of the Cézanne family moved into the area around Aix, where Louis-Auguste Cézanne, Paul's father, was born in 1798. He was a shrewd businessman and managed to rise from the lower-class craft status of his ancestors by dedicating his life to money-making. In Aix he began to work in a firm of wool merchants, then decided to go into the felt hat trade, a considerable source of wealth and a major export item of the local industry. Farmers in the neighborhood bred rabbits and workshops in Aix turned the felt into hats.

In the revolutionary year of 1848 Louis-Auguste seized an opportunity to become a banker and soon became a well-to-do citizen. Earlier Louis-Auguste had met Anne-Elisabeth-Honorine Aubert, with whom he lived before their marriage in January 1844. Their son Paul was born on January 19, 1839, and a daughter, Marie, in July 1841. A second girl, Rose, was born in 1854.

During the seventeenth and eighteenth centuries Aix had been at its most flourishing. By the time of Paul Cézanne's childhood, Marseilles had far outstripped Aix in trade and manufacture, although it did still maintain a leading role in academic education and was the seat of an Archbishop and a Court of Appeal. An antiquated social structure that clearly divided the old aristocracy from the new upcoming bourgeoisie, to which Paul's father belonged, determined the public life in

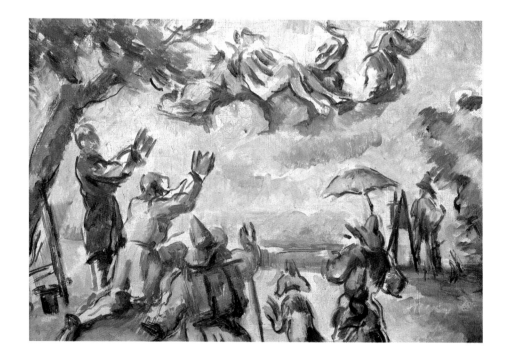

Apothéose de Delacroix
1873–1877; *oil on canvas;* 10 1/2 x 13 3/4 in. (27 x 35 cm.). Paris, Musée d'Orsay.
Like many of the Impressionist painters, Cézanne retained a lifelong admiration for the works of Eugène Delacroix, who is seen in the sky between angels. Below are represented, from right to left, the painters Pissarro, Monet, Cézanne himself with a bag on his shoulders, the collector Victor Chocquet, and another unidentified figure. According to the artist the dog signifies envy, referring to the critics who continued to express their disdain for the art of a new generation.

Five Bathers

1879–1882; *oil on canvas*;
13 2/3 x 15 in. (34.6 x 38.1 cm.).
Detroit, The Detroit
Institute of Art.
*During his years growing up
in Aix, Cézanne went with
Émile Zola and other friends
hiking in the countryside,
where they bathed frequently
during the hot summer
months in the Arc River.
Reminiscences from these
happy moments of his childhood
were to influence the painter
until the end of his life. In
his "Bathers" series Cézanne
attempted an idealized unity
between man and nature in
the tradition of Old Masters
like Giorgione, Titian, and
Rubens. The paintings were
executed in the studio, and the
figures are based on studies of
models or sculptures Cézanne
had copied in the Louvre.*

the town. Religious and devout, Aix was crowded with Franciscans and Jesuits. Their frequent street processions influenced the young Paul, who later in his life became a fervent Catholic.

Another famous son of the city, the writer Émile Zola, was an intimate friend of Paul Cézanne's. In his novels, Zola described life in the Aix of his youth via the fictional name Plassans. "No town kept more fully the devout and aristocratic character that distinguished the old Provençal cities," Zola wrote. The Cézanne family, whom the author knew very well through Paul's countless stories and anecdotes, is reflected in many of his books.

The Early Years

While attending local schools, Paul seems to have shown a sensibility toward art, a tendency that was apparently encouraged by his mother. His father, however, had no interests outside the strict world of business. Little cultivated at the outset of her relationship with Louis-Auguste, Honorine Cézanne seems to have had a fine sensibility, an intelligent mind, and a lively imagination. She was intrigued by art magazines and later supported Paul in his taking courses at the local art school, something that was anathema to her husband. Paul developed a strong sympathy for his mother and her antagonism toward Louis-Auguste influenced the boy's difficult relationship with his father and his omnipresent anxieties.

The strenuous emotional situation in the Cézanne family certainly increased a sense of isolation from the social life in Aix. Louis-Auguste was an upstart, who had—coming from a modest background—pushed himself into the front ranks of the bourgeois of the town. He had lived unmarried with his companion and had begotten two illegitimate children. His sharp tongue and sarcasm did not help win him many friends either.

In 1852, at the age of thirteen, Paul met Émile Zola at the Collège Bourbon. The friendship was very important for both men and lasted until the publication of Zola's novel *L'Oeuvre* in 1886, in which the writer portrays an unsuccessful artist whose character is based upon Paul. Deeply hurt, Cézanne broke forever with his longtime friend.

At school, however, the two boys were nearly inseparable. Both were interested in writing and literature. Paul enjoyed particularly the courses in Latin and Greek. Émile and Paul would write many letters and rhymed verses to each other for the next decade or so in which they expressed their most intimate feelings and emotions together with information about their everyday life. Often the

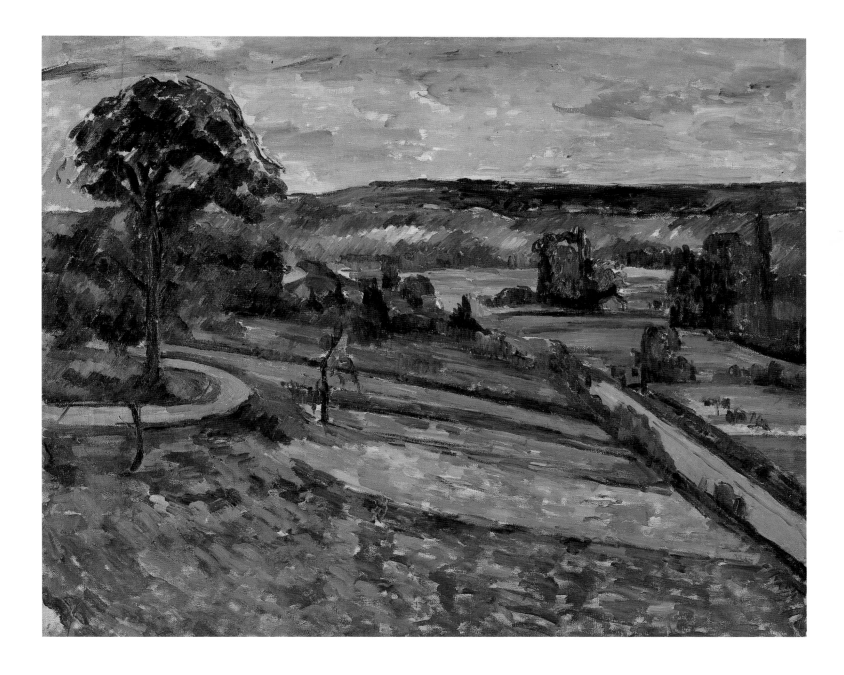

two hiked alone or in company of other friends in the area surrounding Aix, to the Château Noir and the Bibémus quarry, sites which played an important role in Cézanne's late oeuvre. A love for nature and the modest life of a wanderer were already determining elements in the artist's life.

There were, however, many differences between the ardent Zola and the diffident and moody Paul. But as Zola wrote in *L'Oeuvre*: "Opposed in nature, they were bound together at one blow and forever, drawn by secret affinities, the still vague torment of a shared ambition, the awakening of a superior intelligence, in the midst of the brutal mob of abominable dunces against whom they fought."

In February 1858 Zola moved to Paris together with his mother, who saw no longer a future for her family in the town of Aix. Her husband, an engineer, who had been responsible for the design of a canal which to this day provides Aix with drinking water, had died in 1848. Ever

The Tree by the Bend
1881–1882; *oil on canvas; 23 2/3 x 28 3/4 in.* (60 x 73 cm.). Jerusalem, Israel Museum, Gallery of Modern Art.
From 1879 to 1882 Cézanne lived mostly in Paris and its surrounding countryside, at Melun and Pontoise. He also frequently visited Zola at his country estate in Médan, about twenty-five miles from the capital. The exact location of this work has not yet been identified. Cézanne juxtaposed numerous horizontal, vertical, and diagonal planes and contrasted the curvilinear bend of the road on the left with the long lines of the sloping fields and the main road, which leads into the distance.

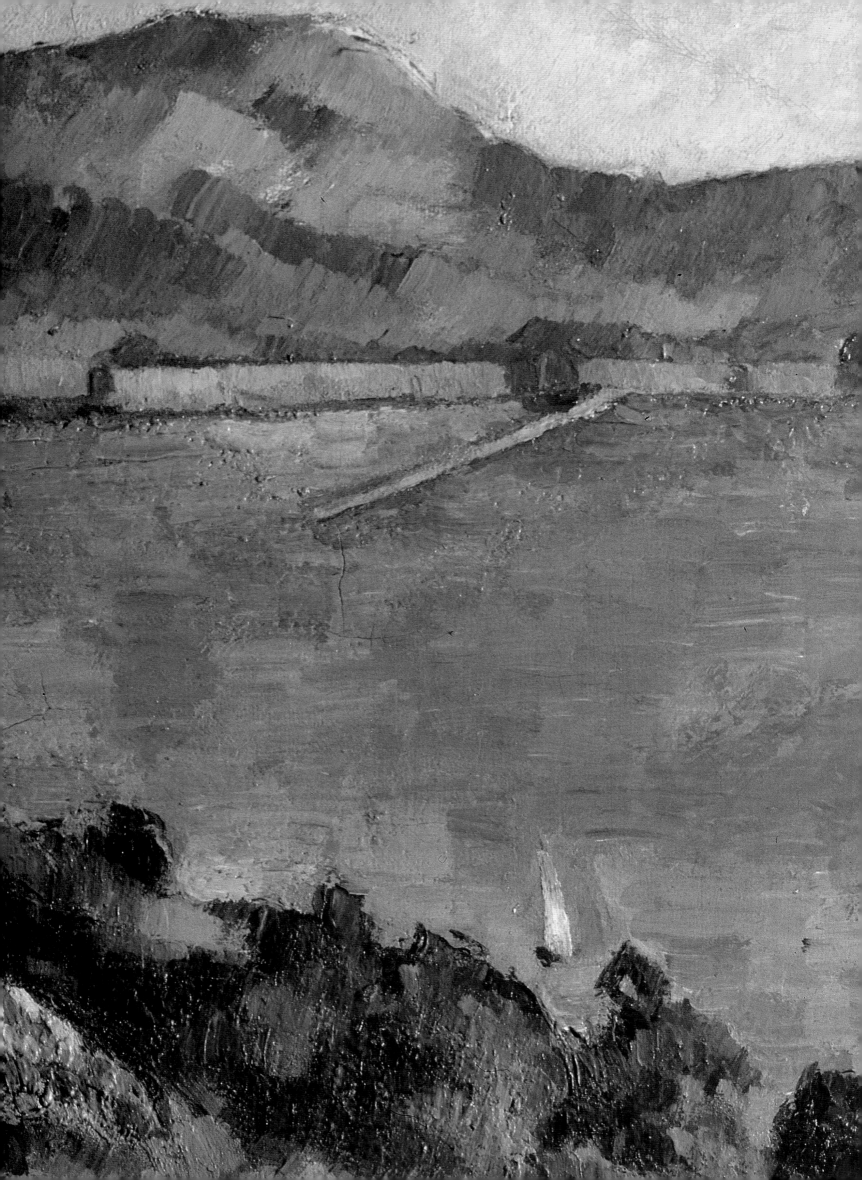

since the untimely death, the Zola family had had to struggle with poverty, a fact that Cézanne's money-conscious father did not find sympathetic. He clearly disapproved of Paul's friendship with Émile, whose provocative and rebellious character he found suspicious.

Artistic Beginnings

Paul and Émile shared a youthful interest in anything romantic, morbid, or decadent, and their letters and poems are vivid testimony to this. As a painter, Paul developed later a certain preference for the motif of the skull. "What a fine thing to paint, a skull," he said, referring to the challenging problems of rendering the object's volume on canvas. But the motif's underlying moroseness goes back to the days of his youth.

From November 1858, Paul attended the free drawing school in Aix. There he met Philippe Solari, son of a stonemason and an aspiring sculptor. Classes were taught by the museum's director, Joseph Gibert, an academic artist who was mainly known for his portraits. Paul began looking seriously at the pictures in the museum, although the collections contained nothing outstanding. Later in Paris he would continue this tradition by copying paintings from Old Masters in the Louvre in order to find solutions for certain aspects of his own paintings.

When in 1861 he finally obtained his father's permission to study art in Paris, Cézanne's first attempt to settle down there failed. Disillusioned with the art world, he returned to his family after only six months and entered his father's bank as a clerk. The following year he went again to Paris, and this time he stayed. Not much is known about these years of study, during which he led a rather frugal life due to his father's meager allowance. Every year he submitted canvases to the artists' Salons, but was regularly rejected. Occasionally he returned for longer periods to Aix but he always went back to Paris, where he had met the circle of artists who would come to be called the Impressionists through his friend and mentor Camille Pissarro, like himself a student at the Académie Suisse.

L'Estaque on the Gulf of Marseilles
c. 1882–1885; detail. Paris, Musée d'Orsay.
Over the years Cézanne returned to L'Estaque on numerous occasions, attracted by the magnificent views of the mountain range in the distance across the gulf of Marseilles. The orange line of a jetty which stretches out into the deep blue sea is actually too long, but in the entire composition it serves as a visual link between the two shores.

A Singular Artist

Cézanne's name is often discussed in connection with the history of Impressionism but his relationship with the Impressionist painters was temporary. Initially the persistent rejection from the official Salon had led artists like Pierre-Auguste Renoir, Claude Monet, Alfred Sisley, Pissarro, and Cézanne himself to form an artist's group which they named the "Society of Painters, Draftsmen, Sculptors, and Engravers." They began to mount their own exhibitions beginning with the first group show in April 1874. Ten days after its opening the satirist Louis Leroy entitled his negative critique about the show "Exhibition of the Impressionists," referring derogatively to a Monet painting titled *Impression—Sunrise*. Thus the origin of the term "Impressionism." Cézanne showed *A Modern Olympia*, *The House of the Hanged Man*, and *Landscape at Auvers*. However, like that of his fellow artists, his works were greeted for the most part with laughter by the public. Cézanne was to exhibit only one more time with this group—at their third show, in 1877. He displayed increasingly a growing feeling of divergence from the group's aims and, although he retained a respect for the work of Monet and Pissarro, he retired more and more within himself. It was, as a matter of fact, this isolated and concentrated effort that led to the extraordinary artistic achievements of Cézanne's mature style.

The small dabs of bright color favored by Impressionist painters did not interest Cézanne. The light and atmosphere his colleagues tried to capture were not the subjects of his paintings. More than once he declared that light did not exist for the painter, that is, at least not for himself. Unlike his artist friends, he generally avoided depictions of modern life and instead painted landscapes and still-lifes of more classical conception. Cézanne's search for fundamental truths and inherent structure in nature, produced an unprecedented degree of abstraction, while Impressionism was more concerned with depicting the effects of outward surfaces. Especially during the early years of his career, Cézanne repeatedly studied the Old Masters in museums; and his approach toward painting out-of-doors was never quite the same as Claude Monet and Camille Pissarro.

Thus his landscapes have no seasonal variance, the people in his portraits little individual character, and the everyday objects in his still-lifes no trivial function. The artist pro-

Embankments of the Marne River
1888; *oil on canvas*; 25 1/2 x 31 3/4 in. (65 x 81 cm.). St. Petersburg, Hermitage. *Around 1888 and until 1890 Cézanne painted various river scenes, especially the banks of the Marne east of Paris. The deep, saturated greens describe a lush, fertile land along the water. At times the dark colors recall his early style, but here the elements of the landscape have been broken down into independent color fields, which in their coherence define the objects as represented in the picture.*

Boy in a Red Vest
1888–1890; detail. Zurich, E.G. Buehrle Foundation. *The white sleeve of the young sitter's arm picks up the green reflections of the tablecloth. The folds are indicated by various color touches of different tonalities and directions, which at first glance appear arbitrary and ambiguous. Yet they are an essential part of the "moving harmony of colored touches representing nothing."*

The Bibémus Quarry
c. 1895; detail.
Essen, Folkwang Museum.
The edges of the rocks follow the rectangular man-made lines. Sunlit areas reflect a deep orange, and shadows are rendered in a dark-brown and occasionally purple tone. The paint in each color patch has been applied with brushstrokes of a different direction, thereby creating a multifaceted surface. The quarry was abandoned during Cézanne's lifetime, but the façades of most of the patrician buildings in Aix were built with materials from this site.

jected his isolation and loneliness onto a natural world which is void of human subjugation, and the composition of his works are as tight and complex as his own personality. His goal was to take the contemporary aspects out of his subjects, to make them appear permanent, eternal. His life in Aix, with its immutable rhythms, determined the iconography of his paintings. While artists in Paris and elsewhere discovered and developed new themes for their works, Cézanne insisted with all his will on his traditional subjects. Street scenes, beaches, parks, or race-courses were of no interest to him.

For almost two decades Cézanne worked for the most part on his own. His solitude was interrupted only occasionally by travels, for instance to Pontoise in 1881, where he stayed again with Pissarro. In 1882, Renoir paid him a visit in L'Estaque, where the two artists painted side by side out of doors. The reclusiveness was not a total one, however, and Cézanne kept informed about developments in Paris, both artistic and literary. Until his break with Zola in 1886 he had read all of his friend's books, and he often went to see the exhibitions in Paris.

His relationship with Hortense Fiquet, begun in 1869, was difficult because he tried to hide her existence before his father out of fear of losing his monthly allowance. He had to pay for her living expenses as well as for their illegitimate son, Paul, born in 1872. Finally, in 1886, after years of painful anxiety, the couple married in the presence of Cézanne's parents. But his newly wed wife was not welcomed at his parents' home, and he had to find a lodging for her and the child elsewhere in Aix. Cézanne himself went on living with his family—his mother and his sister Marie apparently remaining the women who mattered most in his life. The death of his father later the same year did not bring any noticeable change to his immediate existence. Although he inherited a considerable amount of money, Cézanne continued his rather simple and modest lifestyle. And he made no attempt to move closer to his wife and his son, who lived mainly in Paris in later years.

Famous Recluse

The year 1895 marked a decisive change in Cézanne's career. Until then he was practically unknown in Paris, "almost a myth," as the young painter Maurice Denis put it. Since the third Impressionist exhibition in 1877, only two minor works of Cézanne's had been officially shown and his paintings could only be seen in the collections of a few colleagues and enlightened amateurs as well as at the shop of the color merchant Père Tanguy. As late as 1894 the critic Gustave Geffroy could write that Cézanne was "at once unknown and famous . . . a mystery surrounds his person and his work." This situation changed when, urged by Pissarro, Monet, and other Impressionist painters, the dealer Ambroise Vollard organized a show of Cézanne's work at his gallery, which opened in November 1895. This retrospective exhibition contained some 150 pictures, selected by Cézanne himself, who had shipped the canvases from Aix. As a direct result, sales increased and critical discussion of Cézanne's work established his reputation. Other exhibitions followed—again at Vollard's gallery, at the Salon des Indépendants, and at the Salon d'Automne in 1904–06—from which his brilliance as an artist was firmly established and his impact on younger artists like Matisse and Picasso was recognized.

This newly acquired fame had repercussions in his native Aix-en-Provence. Living until then like a recluse, Cézanne emerged suddenly as a public figure among a local group of writers and poets, led by Joachim Gasquet. Gasquet admired Cézanne's renderings of the Provençal landscape and attempted to promote a revival of the Provençal culture and language.

The Pipe Smoker
1895–1900; *oil on canvas;*
36 1/4 x 28 3/4 in.
(92 x 73 cm.). Mannheim,
Staedtisches Museum.
The figure is almost identical to that in Smoker, *which resides in the Hermitage, St. Petersburg. The background is much more simplified here, however, lacking the fragment of a still-life. The model's presence, on the other hand, has a more human touch, with the eyes looking straight out toward the viewer. Like virtually all of Cézanne's figures, the pipe smoker expresses a certain melancholy, which seems to be deeply rooted in his nature.*

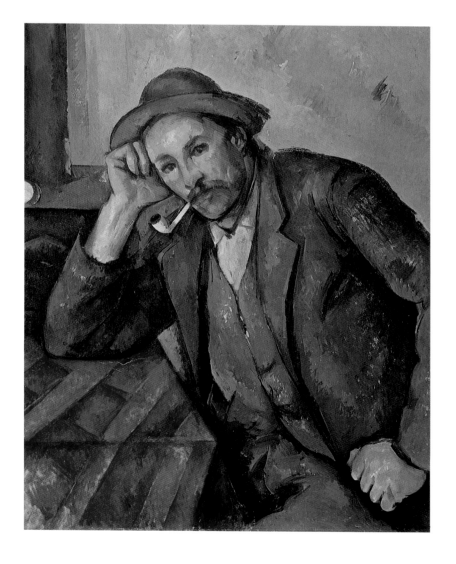

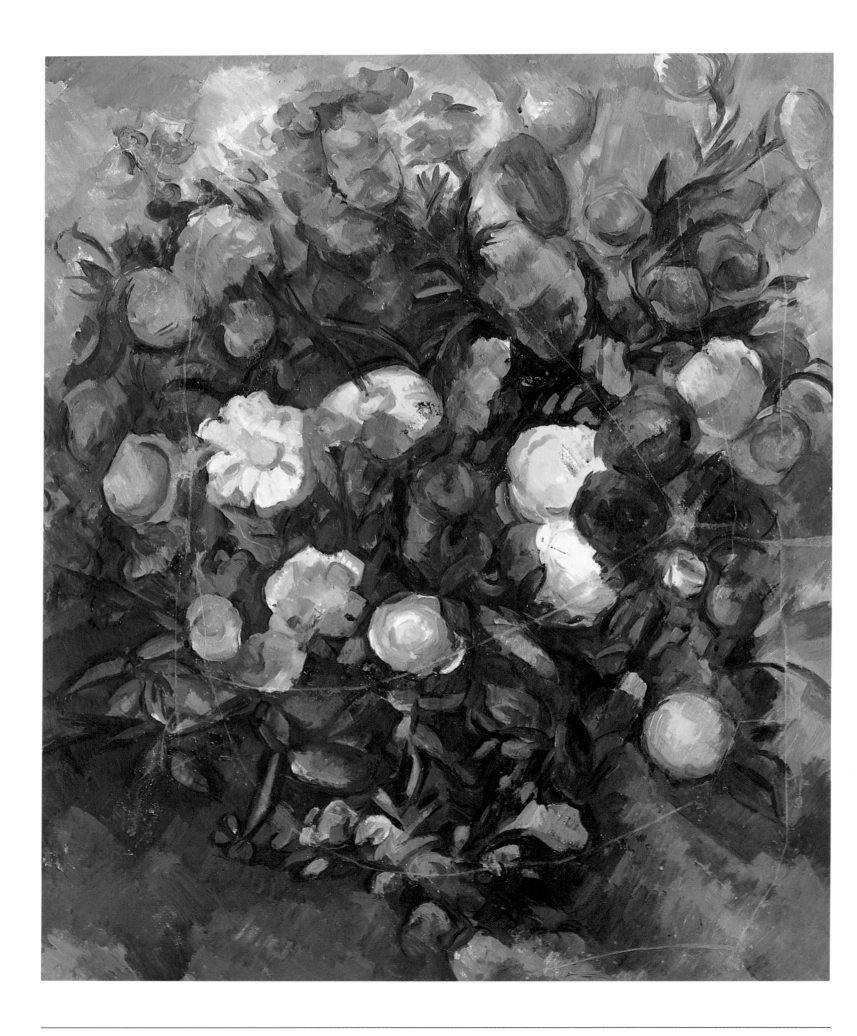

Following the exhibition at Vollard's gallery a steady flow of critical appreciation of Cézanne's art was published. Previously, the only positive review had been that of Georges Rivière, who hailed Cézanne in 1877 in his review *L'Impressionisme* as "a great painter," and stated that "in his works he is a Greek of the great period; his canvases have the calm and heroic serenity of the paintings and terra-cottas of antiquity, and the ignorant who laugh at the *Bathers*, for example, seem to me like barbarians criticizing the Parthenon." Unfortunately such praise was rare before the end of the century. The first major study on Cézanne was Emile Bernard's essay for the weekly biographical leaflet *Les Hommes d'aujourd'hui* (People of Today) in 1891; and a more extensive article of 1904, simply entitled "Paul Cézanne."

In a letter to Émile Bernard on May 26, 1884, Cézanne wrote: "I always turn to this: the painter should dedicate himself wholly to the study of nature and try to produce pictures that are an instruction. Talks on art are almost useless. The work that makes one realize progress in one's own trade is a sufficient compensation for not being understood by imbeciles. The writer uses abstractions for expression while the painter makes concrete, by means of drawing and color, his sensations, his perceptions. One cannot be too scrupulous or too sincere or too submissive to nature; but one is master of one's model and above all of one's means of expression. Penetrate what is before you, and preserve it in expressing yourself as logically as possible." And again a little later: "The Louvre is the book in which we learn to read. But we must not be content to memorize the beautiful formulas of our illustrious predecessors. Let us go out and study beautiful nature, let us try to discover her spirit, let us express ourselves according to our temperaments. Time and meditation tend to modify our vision little by little, and finally comprehension comes to us."

As he had desired, Cézanne painted just about to the last day of his life. While working on a landscape out of doors on October 15, 1906, he was caught in a heavy rainstorm. Drenched and chilled he walked toward home. But the strain was too much for him and he collapsed on the roadside. The illustrious artist was found some time later by a driver of a laundry cart. On the morning of October 23, Cézanne died of pneumonia. He was buried at the old cemetery in his beloved hometown of Aix-en-Provence.

Mont Sainte-Victoire above the Tholonet Road
1896–1898; *oil on canvas*;
30 3/4 x 39 in. (78 x 99 cm.).
St. Petersburg, Hermitage.
The narrow winding road of Le Tholonet is seen from a slightly elevated viewpoint with the Mont Sainte-Victoire in the distance. Two umbrella pines, one behind the other, cast their combined shadow on the road. The paint is applied with thin layers onto the canvas. The bright orange of the earth is complemented by the brilliant green of the vegetation. The subtly modulated mountain is more pink than blue, which has been reserved for the sky alone.

Flowers and Green
c. 1900; *oil on canvas*; 30 1/3 x 25 1/4 in. (77 x 64 cm.).
Moscow, Pushkin Museum of Fine Arts.
This is a free copy of Delacroix's Flowers, *a watercolor from 1847, previously owned by Cézanne's friend collector Victor Chocquet. Cézanne must have first seen it while it was still in the latter's possession. At the auction of the Chocquet collection in 1891 it was acquired by the dealer Vollard, from whom Cézanne eventually received it. In 1904 Delacroix's watercolor was seen hanging in Cézanne's bedroom in his house in Aix.*

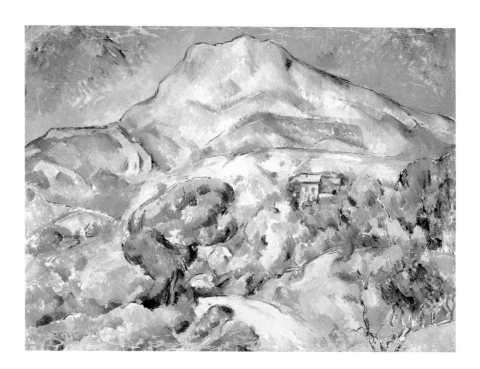

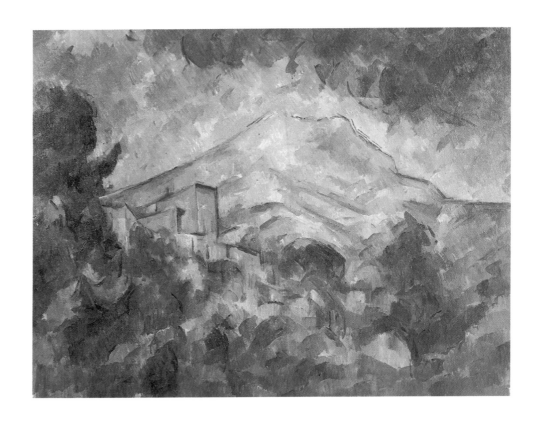

**La Montagne Sainte-Victoire
and the Château Noir**
1904–1906; *oil on canvas;*
25 3/4 x 31 3/8 in. (65.6 x 81 cm.).
Tokyo, Bridgestone Museum of Art.
*As seen from a further distance than
it was in Château Noir, here the
building appears less haunting and
almost dwarfed by the inclusion of
the Mont Sainte-Victoire in the dis-
tance. The glow of the orange-gold
architecture derives from the yellow
stone from the nearby Bibémus
quarry, which also furnished the
material for most of the churches
and the patrician houses of Aix.*

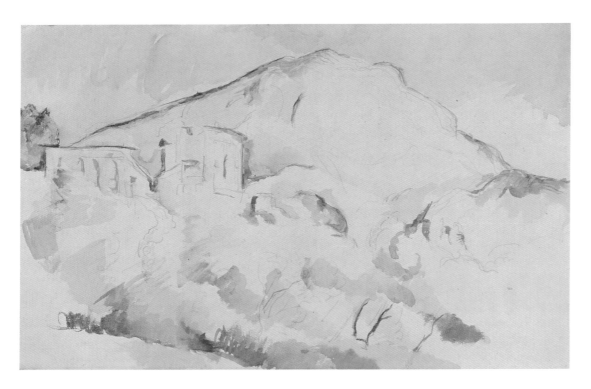

Joachim Gasquet
1896; *oil on canvas;*
25 5/8 x 21 1/4 in.
(65.5 x 54.5 cm.).
Prague, National Gallery.
*Joachim Gasquet posed at
Jas de Bouffan before a
screen which Cézanne
had painted for his father.
Gasquet met Cézanne the
year this portrait was done.
A lyrical and pastoral poet,
he advocated local traditions
and became a strong defender
of the Provençal language.
Unfortunately, he became a
most unreliable recorder of
his friendship with Cézanne
and his observations must
be considered with great care.*

La Montagne Sainte-Victoire
c. 1900–1904; *watercolor;* 12 1/2 x 19 1/4 in. (31.6 x 48.7 cm.). Vienna, Graphische Sammlung, Albertina.
*Utilizing the transparent colors of the medium, Cézanne often made watercolors to study the
effects of light upon nature. In many cases these compositions are similar to photographs taken
of the same views. Here, the mountain is seen together with the Château Noir on the left.
Cézanne chose a similar, but closer, viewpoint in* Mont Sainte-Victoire and Château Noir.
The light washes, which leave most of the paper untouched, convey an airy feeling of space.

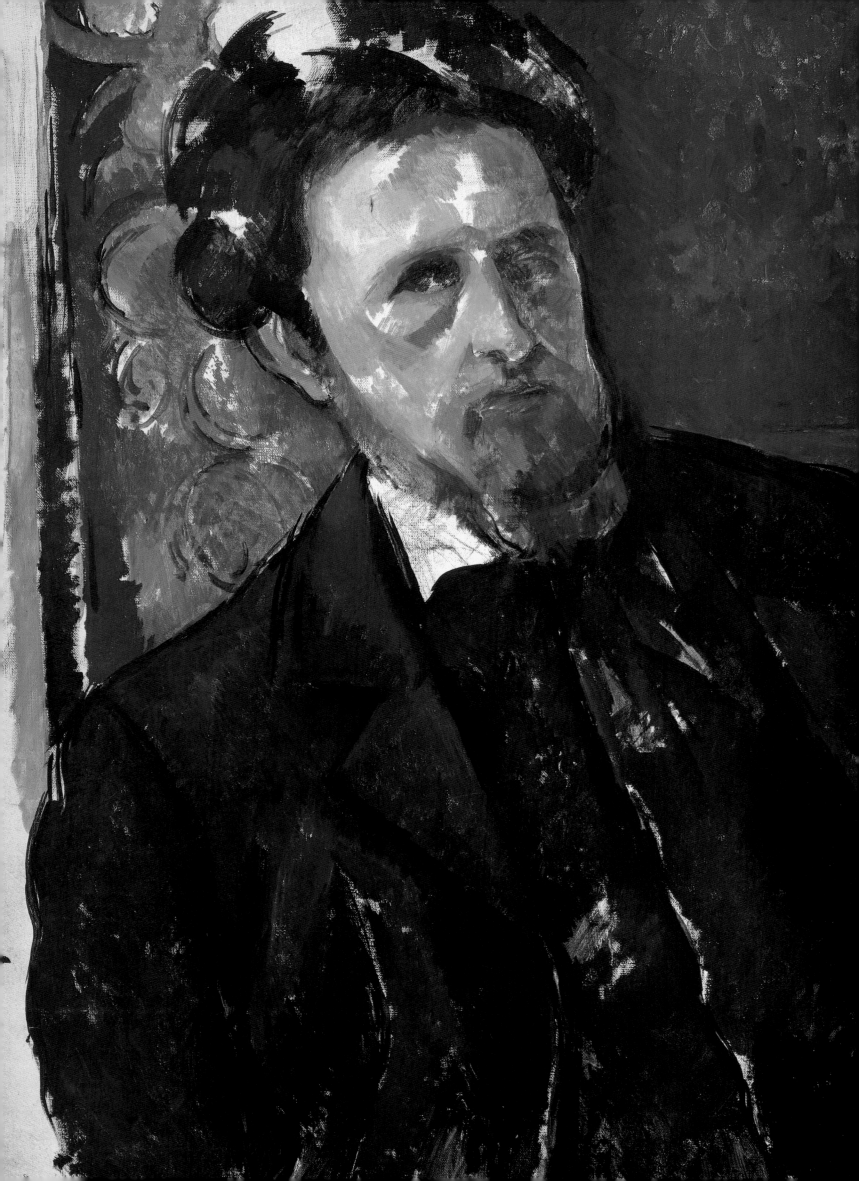

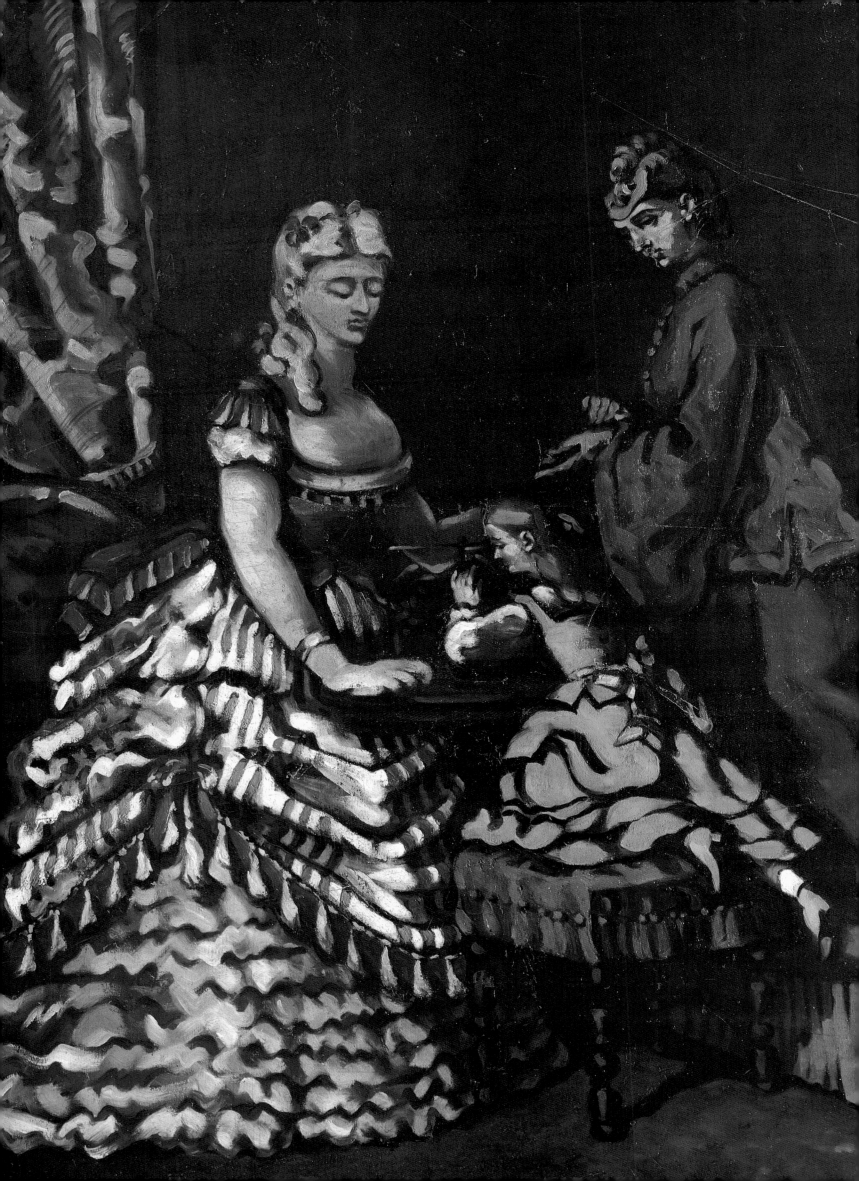

CHAPTER 1

DEVELOPMENT OF A PERSONAL STYLE

*A*mong Cézanne's earliest artistic output are drawings which illustrated his letters to his friend Émile Zola after the latter had moved with his mother to Paris. Cézanne, who stayed in Aix with his family, attended the local Academy after passing his baccalaureate "rather well" in Greek, Latin, Science, Mathematics, and History at his second attempt in November 1858. Because his father insisted that he study law at the university in Aix, Cézanne saw no other choice but to give in and so began his short tenure in this disliked field.

Although the relationship with his domineering father caused problems for Paul, it seems that Louis-Auguste Cézanne showed a greater deal of understanding for his son than is usually believed. After his father bought the seventeenth-century mansion Jas de Bouffan, he apparently allowed Paul to decorate its salon with his panels of the four seasons. Eventually a portrait of the elder Cézanne was added.

First Steps as an Artist

But none of these works was conclusive, and Cézanne's artistic career would have remained little more than an amateurish entertainment had he not convinced his father to allow him to go to Paris, where he desired to study painting. Zola had told him about the artistic life in the city, in particular about the Académie Suisse, where free drawing classes were held. But when Paul finally arrived there in 1861 his expectations were not immediately met. Confused about the Paris art world as well as his own intentions, he resigned and returned to Aix where he worked in his father's bank.

The sheer boredom he endured on the job drove him back to Paris in the fall of the following year. This time he stayed, although his attempt to be accepted at the École des Beaux-Arts art school failed. Instead he continued to frequent the Académie Suisse, where he met Camille Pissarro. The two men struck up a friendship that was to last until the end of their lives. At that time Pissarro was still much influenced by the works of Camille Corot and

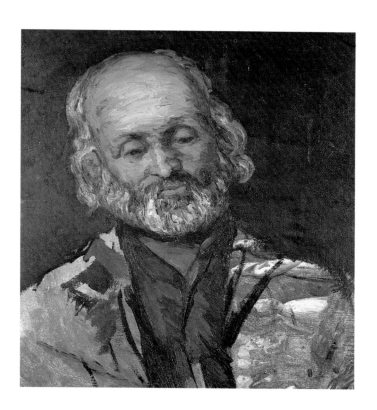

Interior with Two Women and a Girl
1860–1862; *oil on canvas*; 36 x 28 1/4 in. (91 x 72 cm.). Moscow, Pushkin Museum of Fine Arts.
In many of his early works, Cézanne painted with dark colors. Here he used black in the background, but also for the shadows of the faces and folds of the dresses. He might have borrowed the female figures from an illustrated magazine to which his mother subscribed, but it has also been suggested that they actually represent Cézanne's mother and his two sisters, Marie and Rose.

Head of an Old Man
c. 1865; *oil on canvas*; 20 x 18 7/8 in. (51 x 48 cm.). Paris, Musée d'Orsay.
During his early years Cézanne occasionally reused canvases of unfinished pictures that he kept in his studio. The present image is painted over a procession of penitents, which can still be seen in the bottom right-hand corner of the painting. Such pious processions were quite common in Aix. By leaving visible a small section of it Cézanne might have intentionally added a touch of irony to this portrait, which is executed in dense, curving brushstrokes.

River Bend

c. 1865; *oil on canvas*; 12 3/4 x 17 1/4 in. (32.5 x 44 cm.).

Jerusalem, Israel Museum, Gallery of Modern Art.

The paint has been vigorously applied with the palette knife, clearly visible in the white accents on the surface of the river. The predominant dark brown tone of the landscape against a light-colored, almost white sky shows the influence of Gustave Courbet and the Barbizon school. The red-orange and white color dabs promote a sense of depth, while the nervous brush-work in the tree on the right conveys the painter's tense emotional state.

in particular by those of Gustave Courbet, whose palette-knife style and strong contrasts of light and dark masses he had adopted. By 1865 his palette began to lighten up, and the following year found him working consistently in the out-of-doors. Pissarro's generosity and balanced character had a positive influence on the younger Cézanne. In fact, Pissarro served as a mentor to Cézanne.

Not much is known of these years, except that Cézanne went frequently to the Louvre where he copied the works of Eugène Delacroix, Peter Paul Rubens, and Nicolas Poussin, among others. He filled more than twenty sketchbooks with drawings of paintings and sculptures; there are over thirty copies of works by Rubens alone. From this exercise Cézanne learned much about composition and color. Years later, even when his reputation was intact, he would still go to the Louvre in search of solutions for his paintings.

The "Rejected" Artist

Together with Zola, Cézanne made many Sunday excursions into the countryside around Paris. The

"Salon des Refusés" of 1863, where Édouard Manet's painting *Déjeuner sur l'herbe* formed the scandalous center of attention, made a big impression on the aspiring artist. Stirred by such work and considering Manet a symbol of liberation, Cézanne prepared to break with the official Salon painting style. He realized the need to discard all conventional approaches and to look upon the world with fresh, objective eyes. The discussions at the Académie Suisse and with Zola in particular can only have supported him in his conviction.

An example of his work from this period is *Head of an Old Man* (c. 1865), which is executed in dense, curving brush-strokes. This technique, which was typical of Cézanne's style in the 1860s, was temporarily replaced by the vehement palette-knife handling, which became habitual by 1866. That year—a crucial one in his career—Cézanne had once more been excluded from the Salon. Zola reported critically about the Salon in the newspaper *L'Evénement*: "It is not the tree, the countenance, the scene offered to me in a picture that touches me; it is the man whom I find in the work, the powerful individual who has known how to create alongside God's world a personal world which my eyes will never forget and which they will recognize everywhere." It was just such a personal energy that Cézanne tried to introduce into his works through a forceful application of paint to the canvas.

The demonstration piece from 1866 is *Portrait of the Artist's Father* in which Louis-Auguste Cézanne is shown reading *L'Evénement*. This portrait, which must have been painted during a stay at Aix, is somewhat fictional insofar as the elder Cézanne actually never read such a paper. But Paul had chosen to depict this newspaper because it had published Zola's articles. (When the writings were republished the following year in a book, Zola wrote a preface which paid tribute to his old friend.) The portrait has been called "the virtual invention of Impressionist intimacy." Sitting in a tall armchair with flower patterns Louis-Auguste, who wears comfortable house shoes, obviously feels at ease relaxing in his own home. Behind him on the wall hangs a still-life by Cézanne.

The use of the palette knife in this work is a technique he had learned from Courbet via Pissarro. The paint has been crudely applied to the canvas and modeled in thick layers like a relief. The same procedure was adopted in a series of portraits of his maternal uncle, the bailiff Dominique Aubert. In one of them, he has been portrayed facetiously as *The Lawyer (Uncle Dominique)*. Some thirty years later Cézanne referred to this style in his typically coarse manner as *"couillarde"* ("painting with one's balls"). Although this period lasted only for a few months in 1866, it was crucial to the progression of Cézanne's art. By that time he had learned to express his emotions through painting. Underneath the surface of the crudely executed work a sense of order or structure had become apparent.

When he learned about his exclusion from the Salon of 1866, Cézanne wrote to the superintendent of the Beaux-Arts, Count de Nieuwerkerke, demanding a "Salon des Refusés" like the one established three years earlier on behalf of Napoleon III. There was no reply. He wrote again, saying that he refused "to accept the illegitimate judgment of colleagues to whom I have not myself given the authority to appraise me. I write to you then to stress my demand. I wish to appeal to the public and have my pictures exhibited in spite of the Jury. My desire does not seem to me extravagant; and if you ask any of the painters who find themselves in my position, they will all reply that they disown the Jury and want to take part, one way or another, in an exhibition which will be open as a matter of course, to every serious worker. Therefore let the 'Salon of the Rejected' be reestablished." As is well known, the demand was turned down. The letter, which was most likely composed with the help of Zola, is proof of the frustration and anger that pervaded the group of artists who continued to be rejected by the art establishment. Since there was hardly any other public space to exhibit their works, access to the Salon was considered crucial. Independent art dealers and galleries barely existed at that time, and Cézanne had to wait until 1895 to display his art in his way, when the dealer Ambroise Vollard organized for the first time an exhibition of his work.

Artist as Eccentric

A number of dark paintings with violent subjects have seldom found enthusiasts and were little understood even by Cézanne's friends and fellow artists. Pictures like *Strangled Woman* or *The Murder* are more than merely outpourings of the youthful artist's dark moods and impetuous nature. A clue to the understanding of these difficult works can be found in Cézanne's letters and poems to Zola, written earlier, when the future writer had left Aix-en-Provence to live in Paris. In them we encounter descriptions of macabre dreams and fantasies which center for the most part on his family and on women. More traditional in its conception is *The Rape*, painted for Émile Zola, which is actually based on the mythological subject of the rape of Persephone. The figure invention followed a tradition that extended from Tintoretto to Honoré Daumier. The mountain in the distance is the Mont Sainte-Victoire, which was to become one of the artist's last major themes.

With the accomplished and high-energy work *The Negro Scipion* Cézanne returned to a more rhythmic handling of paint. Scipion was a model at the Académie Suisse, though it is likely that this work was painted in Cézanne's own studio. The forceful brushwork models the muscular body and the folds of the blue trousers in a free and spirited way.

Generally speaking, many of Cézanne's early works are centered around the antipodal relationship between man and woman, and their various forms of confrontation. They reflect the personality, sensibility, and conflicts within the artist himself. For in the alienation of the sexes is revealed nothing less than Cézanne's own lack of human relationships. The paintings clearly reveal the striking emotions which led to their creation. As a man and an artist, Cézanne was entirely isolated. He never managed to completely escape from the control of his family, and even as an old man in his hometown Aix-en-

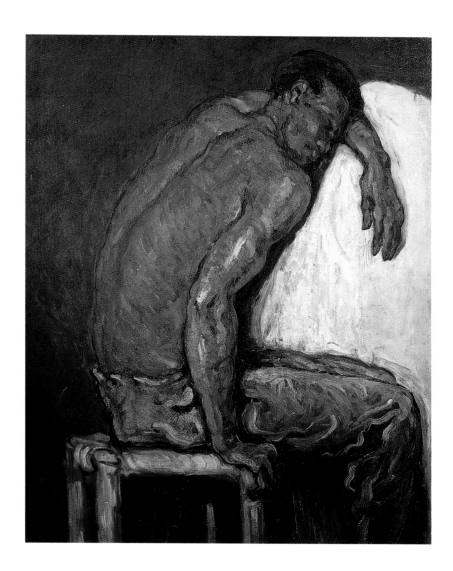

The Negro Scipion
c. 1867; *oil on canvas*; 42 1/8 x 32 5/8 in. (107 x 83 cm.).
São Paulo, Museu de Arte.
The figure in this picture was a model at the Académie Suisse in Paris, where the artist often went to draw from life, although here he appears to have posed in Cézanne's own studio. The paint has been applied with rhythmic, swirling brushstrokes full of energy, modeling vigorously the muscled body. Claude Monet, who once owned the painting and which he kept in his bedroom, liked to point it out as a "piece of utmost power."

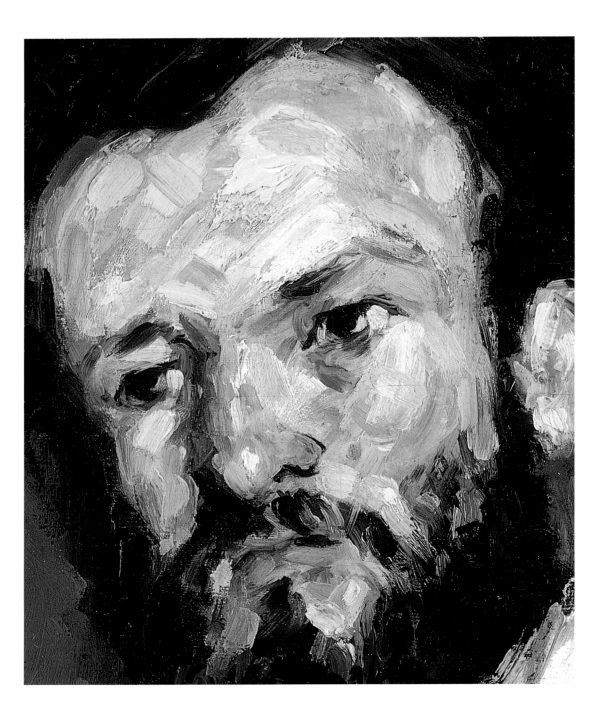

Portrait of Antony Valabrègue
c. 1869–1871; detail.
Malibu, California,
The J. Paul Getty Museum.
The brown, black, pink, and white paint has been applied with considerable confidence and vigor, forming a lively contrast between the light hues of the flesh, which is framed by the dark hair and beard. The sunken black eyes under a high forehead express assuredness and dependability. The sitter's ebullient strength of character can be compared to that of Cézanne's father, Louis-Auguste.

Provence he suffered under the bigoted benevolence of his sister.

His lack of social skills also became evident at the meetings of Impressionist artists and their friends at the Café Guerbois, where Pissarro occasionally took him. Besides Manet, who was the oldest in this group, one could find there, among others, artists such as Monet, Renoir, and Sisley. Artistic issues were frequently debated, at times with great fervor. "Nothing could be more interesting," Monet later remembered, "than these 'causeries' with their perpetual clash of opinion. They kept our wits sharpened, they encouraged us with stores of enthusiasm that for weeks and weeks kept us up, until the final shaping of the idea was accomplished. From

them we emerged with a firmer will, with our thoughts clearer and more distinct." Monet noticed also that, as soon as Cézanne arrived, he threw upon all the assembly a scornful eye and remained mostly silent in a corner, appearing to take no interest in the talk going on around him. But when he heard something that irritated him, he rose abruptly and left the room without saying good-bye to anyone. Although he admired Manet's work, he disdained the older artist's urbane refinement and sharp wit. Dressed as a true bohemian in an enormous overcoat which the rain had streaked green, bright blue stockings below short trousers, and a battered felt hat, Cézanne's appearance must have been a striking contrast to the worldly elegance of Manet.

Edmond Duranty, art critic and novelist, described in a short story an artist who was clearly understood to be a somewhat harsh caricature of Paul Cézanne. The narrator, eager to visit the painter's studio, arrives at the door with some trepidation: " 'Enter', he heard, in a voice redolent of the south of France. What he saw there was the room of a rag picker, a 'chiffonier.' Dust, garbage, old clothes and pieces of broken dishes were piled everywhere; a smell of mold permeated his nostrils. Then he saw the painter called Maillobert. He was bald with a great beard, and gave the impression of being both young and old at the same time, somehow personifying the symbolic divinity of his own studio—indescribable and sordid. He gave the visitor a grand salute accompanied by a smile that was indefinable; it might have been either bantering or idiotic. At that his eyes were assailed by enormous canvases hung in every direction, so horribly painted, so wildly colored that he stood petrified. 'Aah,' said Maillobert, with his slow, exaggerated Marseillaise accent, 'Monsieur is a lover of painting! Observe! These are merely the small scraps from my palette,' and he pointed to the huge sketches thrown about the room."

Although this story certainly contains poetic license, much of the popular legends that surrounded the artist proved to be accurate. Cézanne was known to be "very odd," at once violent and gentle, timid and proud. Duranty met regularly with the circle of artists at the Café Guerbois and must have gathered some firsthand information there.

Women and other Acquaintances

Cézanne's repressed sexuality is manifest in one of the most enigmatic works from his so-called romantic early period, *The Temptation of St. Anthony* (c. 1877). Inspired by Gustave Flaubert's novel of the same name, the traditional subject expressed an essential part of Cézanne's personality: his ambiguous attitude toward women. A monastic saint, none other than the artist himself, confronts his individual tempter in the distance on the left. Yet his figure appears on the same scale as that of the three female nudes in the foreground, who appear to be oblivious to the male intruder. It has been noted that the figure on the right near the fire bears strong masculine features, and some critics have interpreted it as a representation of his friend Zola. In any case, his ambiguous character and melancholic, contemplative pose is not befitting in a scene of such tempting sensuousness.

Richard Wagner's opera *Tannhäuser*, performed in Paris in the spring of 1861, also features a hero who struggles between the conflicting realms of the senses and the spirit. The production caused a controversy in Paris, and Wagner withdrew the score after only three

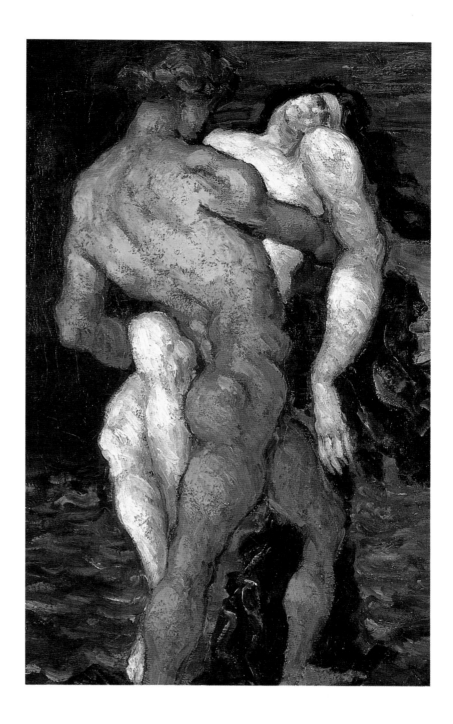

The Rape

c. 1867; detail. Fitzwilliam Museum
By kind permission of the Provost and Scholars of
King's College, Cambridge
The glowing orange of the muscular male figure contrasts effectively with the lifeless pale woman the man is about to carry off. Her black hair echoes the downward movement of the dark blue veil falling behind her toward the ground. Her flaccid limbs are not harmoniously linked to her body, while the male figure is far more accurately modeled.

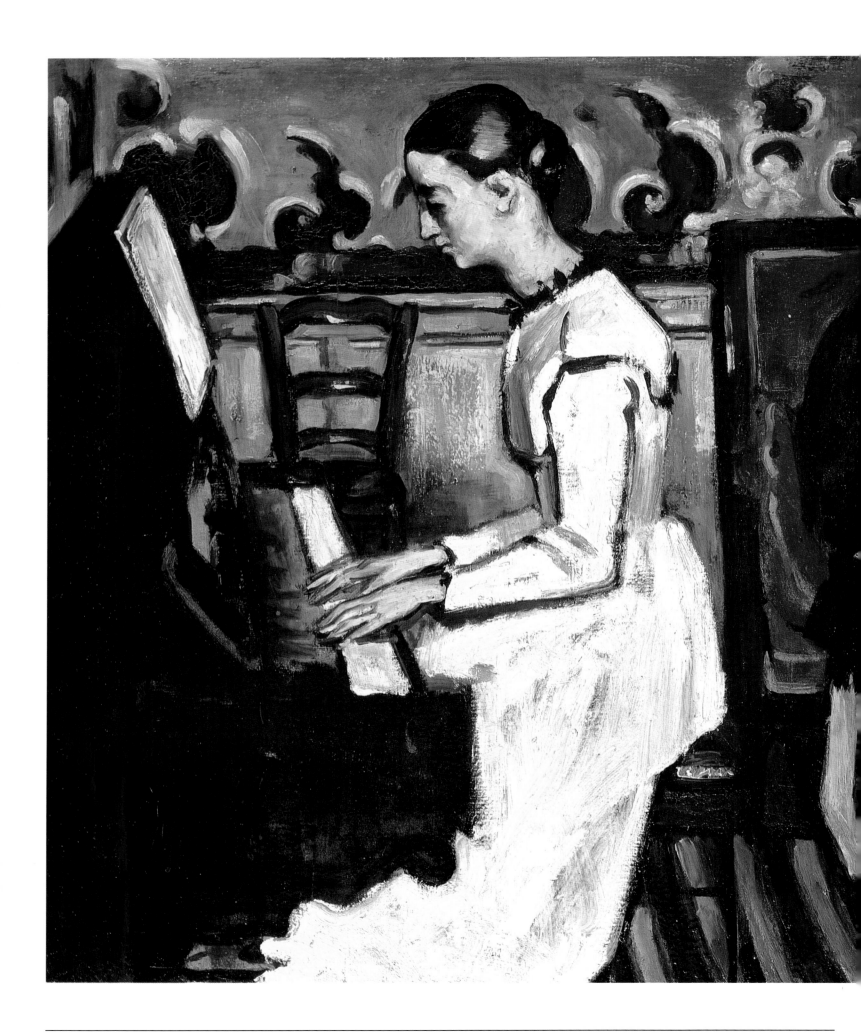

Young Woman at the Piano ('Tannhäuser Overture')

1869–1870; *oil on canvas;*
22 1/2 x 36 1/4 in.
(57 x 92 cm.).
St. Petersburg, Hermitage.
The two sitters might have been Cézanne's cousins. Earlier versions of the work included Cézanne's father sitting in the armchair on the right. The enlarged arabesque motif of the wallpaper identifies the room as a salon in the Jas de Bouffan. Similarly stylized wallpaper can be found in works by Henri Matisse, painted a generation later. Enthusiasm for Richard Wagner's music was common among young Frenchmen in the 1860s and Charles Baudelaire praised the Tannhäuser Overture *as "voluptuous and orgiastic."*

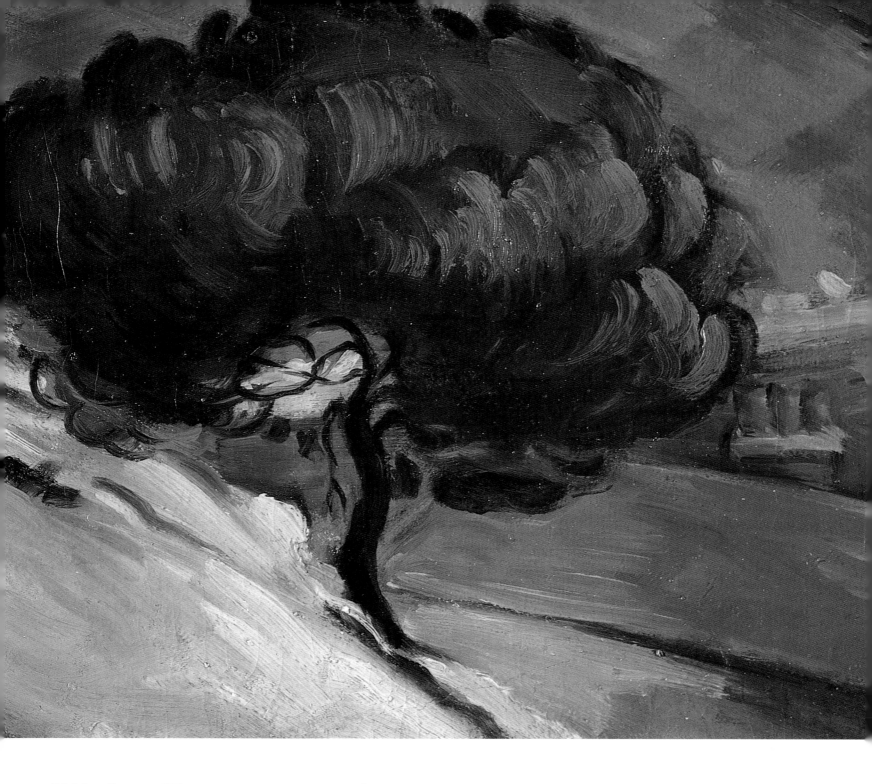

Melting Snow at L'Estaque
c. 1870; detail.
Zurich, E.G. Buehrle Foundation.
A twisted tree is threatened by melting snow sliding down the slope. Its foliage is rendered with thick, curved brush-strokes of green, ocher, and black hues, while the rooftop of the house with its broadly applied red paint assumes a function of stability. Some yellow and ocher touches on the roof as well as some white dots on the chimneys relate to the landscape elements in the work.

performances. Cézanne was certainly well informed about these events, which had quickly achieved a mythic status aided by the poet and critic Charles Baudelaire's eloquent defense of the composer. In an 1865 letter Cézanne mentions "the noble tones" of Wagner's music that he had enjoyed in a concert. In the title of his painting *Young Woman at the Piano (Tannhäuser Overture)* he paid tribute to the composer's controversial opera. In addition to the opera's subject, perhaps also the outsider role of the genial composer attracted the young painter, who himself felt misjudged and misunderstood by his contemporaries.

The friendship with Zola continued to be of great importance to Cézanne, although their relationship had become less intense as the years passed. In his novels *Thérèse Raquin* (1867) and *Madeleine Feirat* (1868), and more so in his monumental Rougon-Macquart cycle, Zola reveals an intimate knowledge of his friend's psyche, both as an individual and as an artist. It remains questionable, though, if the writer was able to fully appreciate Cézanne's art. Contrary to his friend, Zola had assumed a prominent role among the group of future Impressionist artists. In 1868 Manet rewarded the young writer for his strong vocal support with a portrait.

Meanwhile, Cézanne's style remained in a state of turbulent development. In *Paul Alexis Reading to Émile Zola* he painted his friend while listening to his new secretary from Aix, Paul Alexis. The two men are sitting in the garden at the rue La Condamine, where Zola was then living. Each figure is closed within himself, and there is no clear interaction between them. Sitting on a floor mat, the "pasha of Realism" appears to be listening in a brooding mood. His figure is unfinished and his pose is yet unresolved. There are no reflections or color-conflicts playing over the surfaces. Dark greens and blacks are the dominant hues. The painting does not seem to have found much appreciation with its owner and was discovered in his attic after Madame Zola's death in 1927.

Among the artist's circle of friends from Aix was Antony Valabrègue, a young writer who was also on close terms with Zola. *Portrait of Antony Valabrègue* is executed with a spontaneous vigor and refinement that exceeds even the pictures of Cézanne's uncle Dominique. The sitter has an air of self-assuredness and dependability, which must have appealed to the rather volatile and insecure Cézanne. Just how close the world of writers and artists was at this time is illustrated in a statement written by Zola in a letter to Valabrègue, in which he elaborates on the metaphor of his "screen thesis": "Every art work is a window opening out onto creation: stretched taut in the window frame is a sort of transparent screen, through which one can see objects that appear more or less distorted because they undergo more or less palpable alterations in their lines and colors. These alterations have their origin in the nature of the screen." Cézanne must have known of this theory, which no doubt helped him to clarify his thoughts about the role played by the creative mind in relation to nature.

Another friend from Aix was the painter Achille Emperaire, who despite his poverty was ambitiously devoted to his art. Joachim Gasquet described him as "a dwarf, but with a magnificent cavalier's head, like a van Dyck, a burning soul, nerves of steel, an iron pride in a deformed body, a flame of genius on a warped hearth, a mixture of Don Quixote and Prometheus." Cézanne's *Portrait of the Painter Achille Emperaire* shows him in his bathrobe sitting in the same type of armchair as Cézanne's father had in his portrait. The style of the painting is brutal yet sympathetic. The large head expresses a strong will and contrasts with the shrunken body and the short legs, which do not reach the ground. The sitter's name is written in bold letters above his head together with the title of his profession, a feature that is probably derived from Tintoretto's self-portrait in the Louvre. The difference between this painting and the portrait of Cézanne's father is striking. The tonal impressionism of the earlier picture has been replaced with a resolved and simplified scheme in which the figure appears with clearly defined contours. Every element with its own independent, monumental life, has become a thing in and of itself. The painting was submitted to the 1870 Salon together with a reclining nude, now lost. Both pictures were rejected. A caricature of Cézanne and these two works appeared in the *Album Stock* together with an interview: "The artists and critics who happened to be at the Palais de l'Industrie on March 20, the last day for the submission of paintings, will remember the ovation given to two works of a new kind . . . Courbet, Manet, Monet, and all of you who paint with a knife, a brush, a broom or any other instrument, you are all outdistanced! I have the honor to introduce you to your master: M. Cézannes [sic] . . . Cézannes hails from Aix-en-Provence. He is a realist painter and, what is more, a convinced one. Listen to him rather, telling me with a pronounced Provençal accent: 'Yes, my dear Sir, I paint as I see, as I feel—and I have very strong sensations. The others, too, feel and see as I do, but they don't dare . . . they produce Salon pictures . . . I do dare, Sir, I do dare . . . I have the courage of my opinions—and he laughs best who laughs last.'"

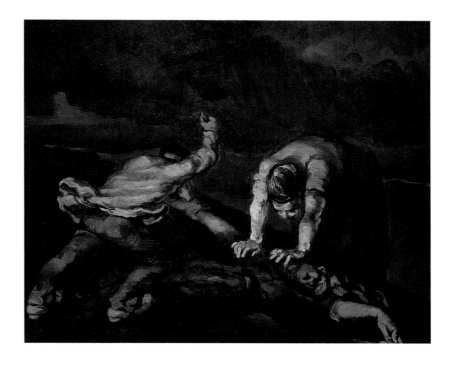

The Murder
c. 1867–1868; *oil on canvas*; 25 3/4 x 31 1/2 in. (65.6 x 80.5 cm.).
Liverpool, Walker Art Gallery.
Possibly based on a popular print, this scene shows an unbalanced presentation of a violent act of murder. The distortion of the composition is especially evident in the right figure, bending over the woman's body with her face partially visible, and in the long, outstretched arms of the victim, lying on the ground like a Christ figure about to be nailed onto the cross.

At the end of May 1870, Zola was married. Cézanne and three other friends from Aix were witnesses. The previous year Cézanne had met a young girl named Marie Hortense Fiquet, with whom he was soon living. Born in a village in the Jura, she was about ten years his junior. Her family was poor and she earned a little money by sewing handmade books and by posing as an artist's model. It was doubtless in this latter role that she encountered Cézanne, although nothing is known about their first meeting. It has been said that Cézanne's relationship to Hortense has had no influence upon his art. This statement, however, is contradicted by the artist's later works, in which the anxieties of this early period of their relationship have subsided somewhat and he was able to utilize Hortense as a sitter for several portraits.

When in July 1870 Prussia declared war on France, out of fear of conscription into the army Cézanne went first to Aix, then to L'Estaque, west of Marseilles, where his mother owned some property. He secretly took Hortense with him, always wary of his father finding out about her existence. Although Louis-Auguste had agreed to pay a monthly allowance to his son, which had even been increased over the years, Cézanne still felt the strict reign of his parents who, he believed, at any given moment could stop the payments. Paul's relationship with Hortense vis-a-vis his father is a complex, guilt-ridden story full of pain and anxiety for the artist (as well as for Hortense, no doubt) until their marriage in 1886, shortly before Louis-Auguste's death, finally broke the spell.

The Beginnings of a Mature Style

The winter of 1870–71 was a cruel one, and it even snowed at L'Estaque. There, during the war, Cézanne painted several works while dividing his time between the countryside and his studio. He followed closely the news of the events, which did not leave him unaffected. In fact *Melting Snow at L'Estaque* is a fearful image of a world dissolved. Snow slides downhill in a precipitous diagonal under a dark, gloomy sky. Everything is unstable and foreboding. Significantly, at this time Cézanne had finally turned to painting out-of-doors, as advocated by Pissarro and other Impressionists. From now on he became more and more preoccupied with landscape painting.

Cézanne remained in L'Estaque throughout the war as well as during the period of civil upheaval that followed in Paris, known as the Commune. He returned to Aix in March 1871 and later on to Paris, where on January 4, 1872, Hortense gave birth to a son, who was named Paul. In the fall, Cézanne followed Pissarro's invitation and moved to Pontoise, where a close collaboration between the artists began. At the end of the same year the young family moved again, now to the rural village of Auvers, not far from Pontoise, where the landscape painter Charles-François Daubigny and the amateur artist Dr. Paul Gachet lived. Under Pissarro's influence, Cézanne's palette began to lighten. Soon he abandoned his more impetuous style and concentrated his efforts on a more painterly, meditative process.

Paul Alexis Reading to Émile Zola

c. 1868–1870; *oil on canvas*; 51 1/8 x 63 in. (131 x 160 cm.).
São Paulo, Museu de Arte.
Paul Alexis, the amanuensis of Émile Zola and a friend of Cézanne's, was also a native of Aix. Sitting on a chair in the writer's garden at the rue La Condamine, he is reading from a manuscript to Zola, who is stretched in a hastily defined pose on a blanket on the ground. The influence of Manet can be felt in the contrast of the dark and light colors combined with an almost turquoise green. The painting was found in the writer's attic after Madame Zola's death in 1927.

Sorrow, or Mary Magdalen

c. 1867; *oil on canvas*; 65 x 48 3/4 in. (165 x 124 cm.).
Paris, Musée d'Orsay.
Originally part of a larger canvas with the subject "Christ in Limbo" (now in a private collection), the composition was divided in two parts when it was removed from the wall of the salon at the Jas de Bouffan, possibly because of the disproportion of its parts. Long, curved brushstrokes are energetically applied, as in the skull on the right in front of which Mary Magdalen meditates, or in the folds of her shirt's sleeve. The three bright-red tears above represent her sorrow.

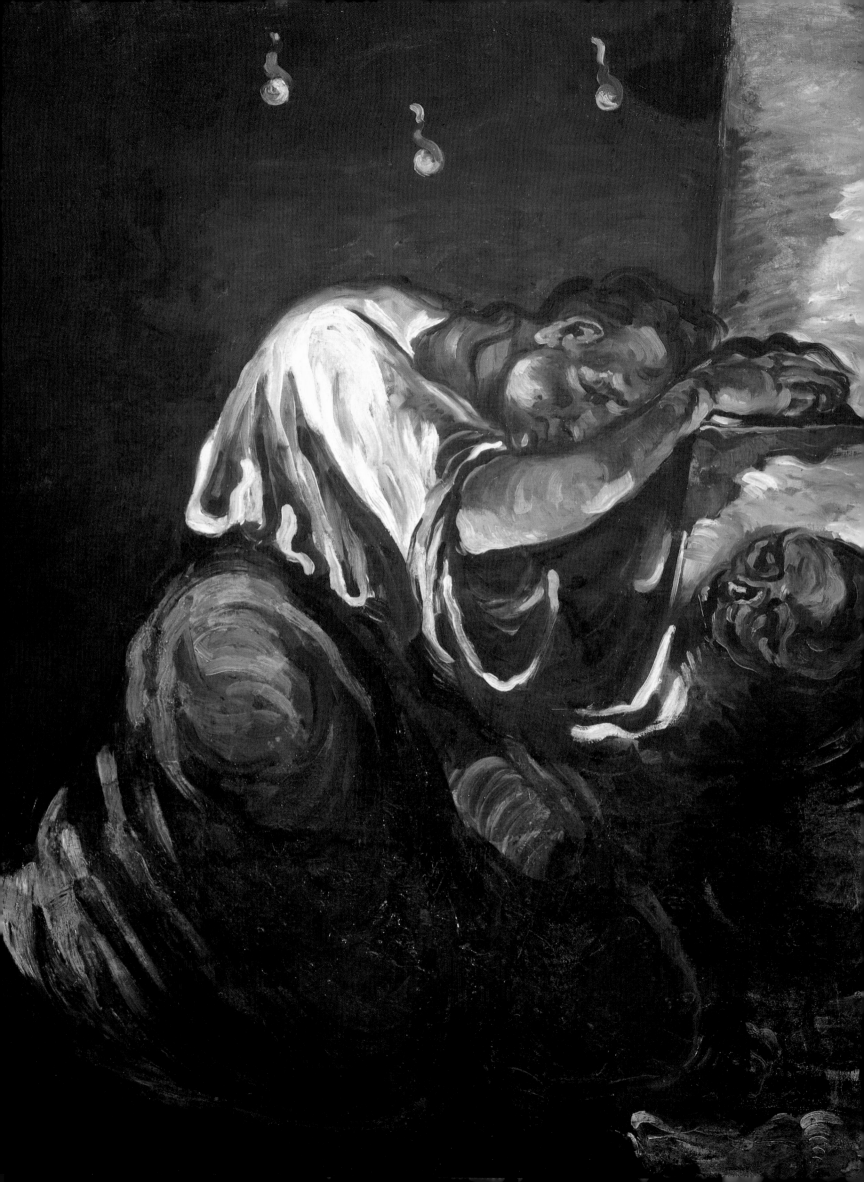

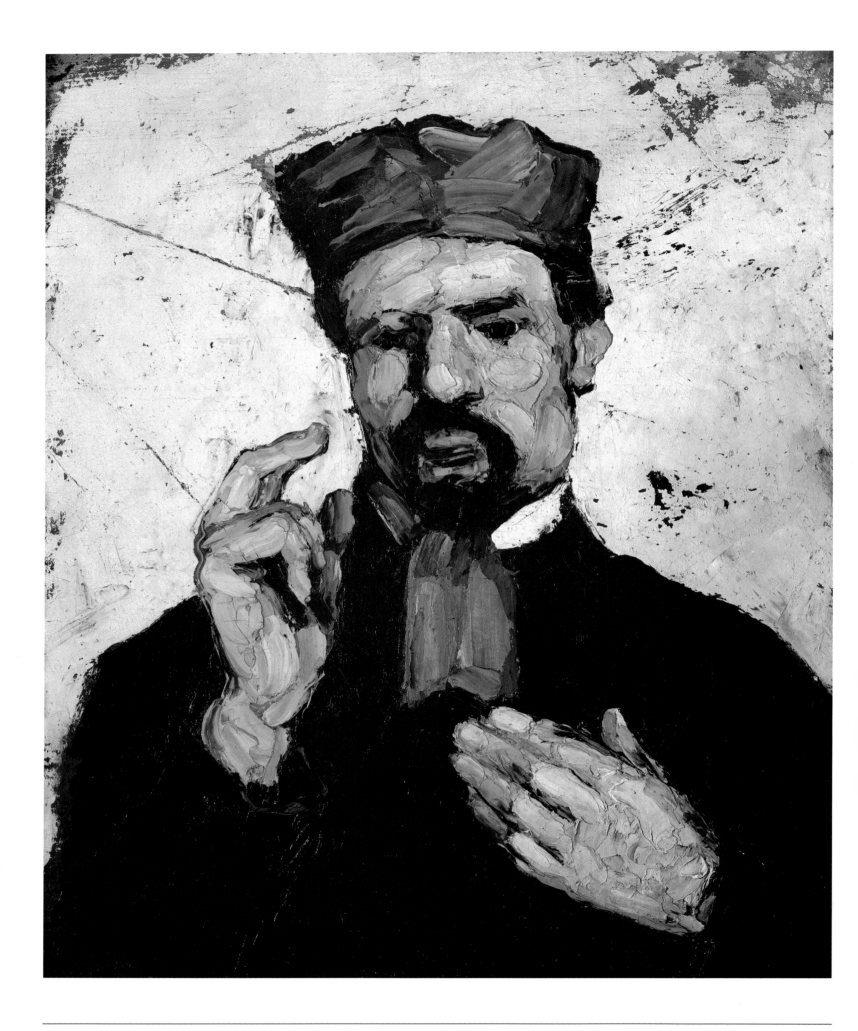

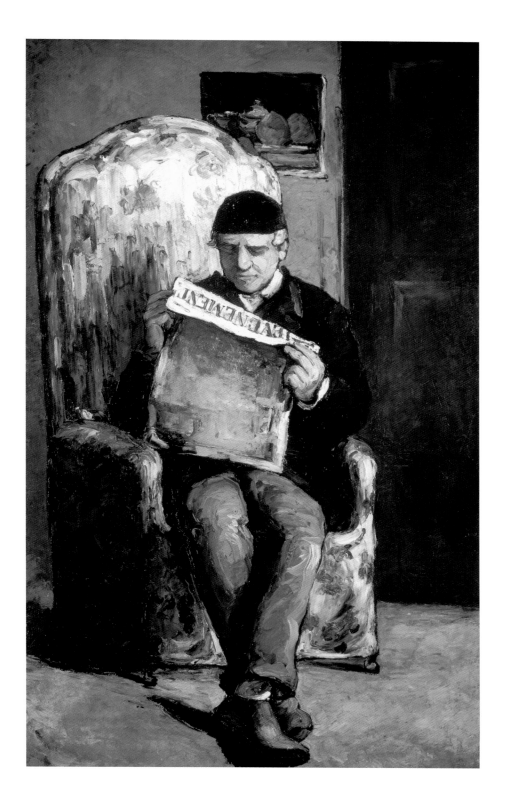

The Lawyer (Uncle Dominique)
c. 1866; *oil on canvas*; 24 1/4 x 20 1/2 in.
(62 x 52 cm.). Paris, Musée d'Orsay.
In a series of paintings Cézanne's
maternal uncle Dominique sat
patiently as a docile model. At one
time dressed as a Dominican monk,
here he is shown in the attire of
a lawyer at court in the tradition
of Honoré Daumier. These works
are often characterized by the furious-
ly-handled palette knife with which
the artist built up thick reliefs of
paint, precisely placed to model form
inside the lines of black contour.

The Artist's Father
1866; *oil on canvas*; 78 1/8 x 47 in. (198.5 x 119.3 cm.).
Washington, D.C., National Gallery of Art.
Cézanne's father, Louis-Auguste, is sitting in a flowered armchair reading the
newspaper L'Evénement, *which published articles by the painter's friend, Émile*
Zola, also a native of Aix. The still-life on the wall behind the chair is one of
Cézanne's own paintings, today in the Musée d'Orsay, Paris. This is the artist's
major work among the pictures executed with the palette knife. Its personal and
intimate atmosphere is a feature soon taken up by the Impressionist painters.

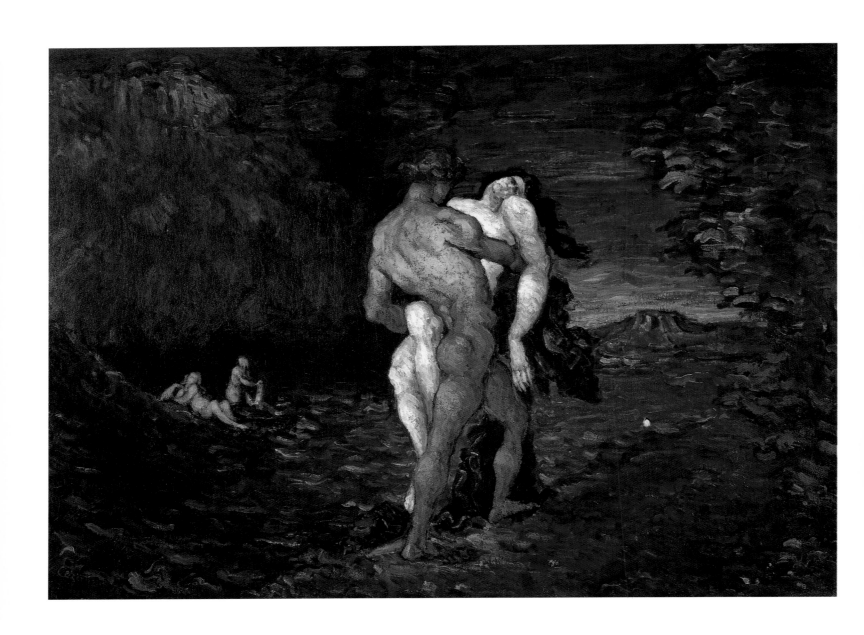

The Rape

c. 1867; *oil on canvas;* 42 x 61 1/4 in. (89.5 x 155.5 cm.). Fitzwilliam Museum.

By Kind permission of the Provost and Scholars of King's College, Cambridge.

This rather conventional composition might actually represent a mythological scene: the
abduction of Persephone by Pluto, King of the Underworld. It was painted for Émile Zola,
perhaps in his house in Paris in the rue La Condamine. Zola might have asked Cézanne to sign
and date this picture, something the artist did only rarely. The forceful male figure, carrying off
a fair-skinned woman, shows a certain resemblance to the muscled body in The Negro Scipion.
The mountain in the distance appears to be the silhouette of Mont Sainte-Victoire.

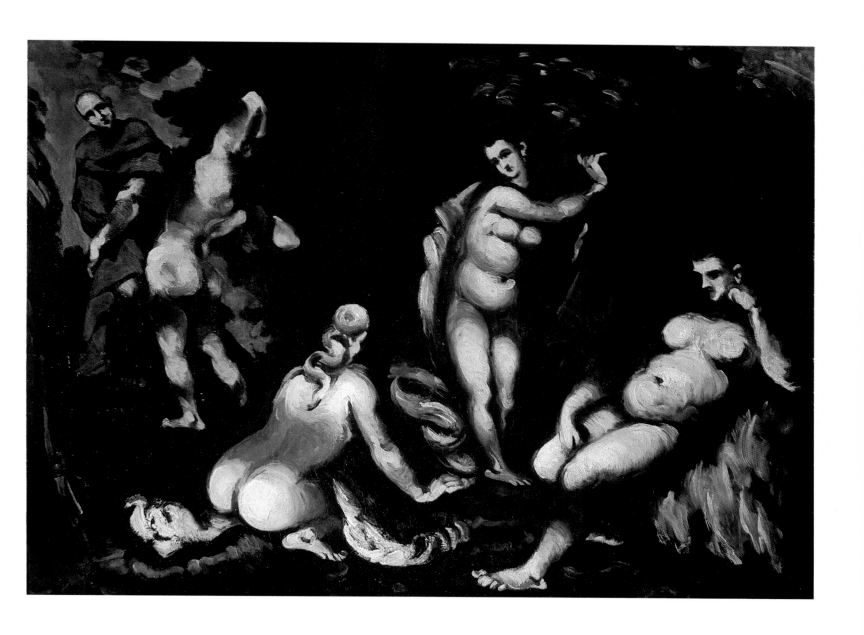

The Temptation of St. Anthony

c. 1870; *oil on canvas;* 21 1/4 x 29 3/4 in. (54 x 73 cm.).

Zurich, E.G. Buehrle Foundation.

This work was inspired by Gustave Flaubert's novel of the same title,
which was published in 1856. The actual temptation scene takes place in
the far left corner, where a female nude, whose pose is based on one of
Michelangelo's "Slaves" in the Louvre, makes advances toward the saint.
The focus of the composition is, however, on the group of three figures in the
foreground, which recalls scenes of the Three Graces or the Judgment of Paris.

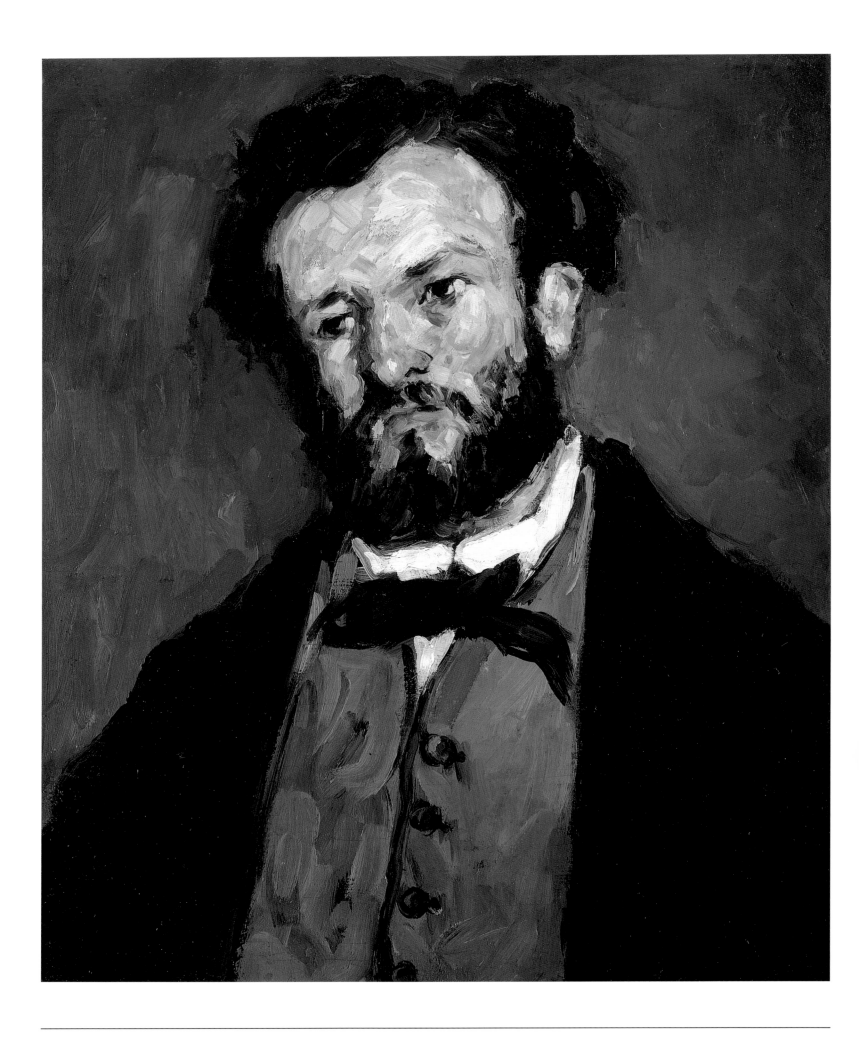

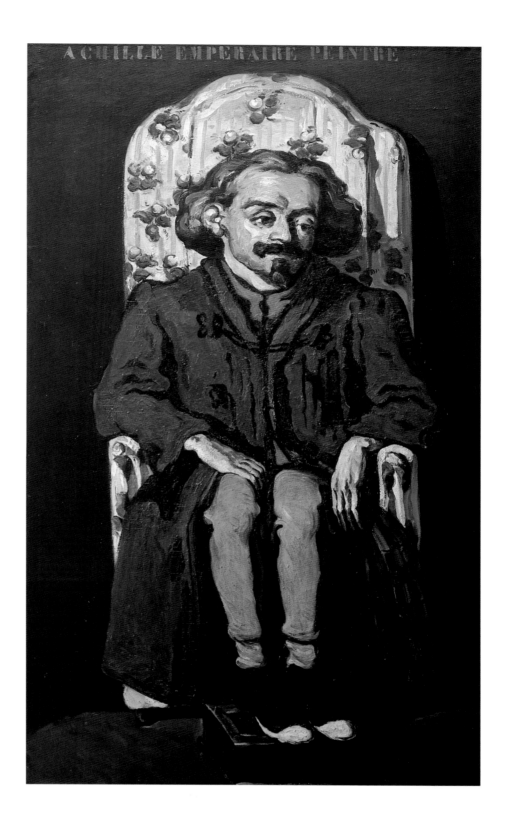

Portrait of Antony Valabrègue

c. 1869–1871; *oil on canvas*;
23 5/8 x 19 3/4 in. (58 x 48.5 cm.).
Malibu, California,
The J. Paul Getty Museum.
A writer, critic, and historian,
Antony Valabrègue befriended
Cézanne early in his life. As
Antoine Guillemet told Zola,
Valabrègue was writing a poem
a day with a surprising fertility.
Later he lost touch with Cézanne
altogether. This is one of three
known portraits of Valabrègue,
executed with vigor and a refine-
ment that was quite unprecedented
in Cézanne's work. The sobriety
of this painting has been compared
to that of Manet's work.

Portrait of the Painter Achille Emperaire

c. 1868–1870; *oil on canvas*; 78 3/4 x 48 in. (200 x 122 cm.). Paris, Musée d'Orsay.
Cézanne depicted his painter friend Achille Emperaire seated on a patterned
armchair that literally dwarfs the sitter, who was an afflicted cripple. His
legs are too short to reach the ground, the long thin hands are hanging
down in a powerless gesture, and the head is slightly turned aside as if in
resignation. The purplish-colored hair echoes the undulating shape of the
top of the chair, stressing the hieratic structure of the composition.

Melting Snow at L'Estaque

c. 1870; *oil on canvas*; 28 1/2 x 36 1/4 in. (72.5 x 92 cm.).
Zurich, E.G. Buehrle Foundation.
Cézanne escaped conscription into the army during the
Franco-Prussian War by spending the winter months
of 1870–71 at L'Estaque, on the Mediterranean near
Marseilles, together with his future wife, Hortense
Fiquet. The snow he witnessed there was a rare event
and prompted him to paint this landscape. Under a dark,
gloomy sky a snowfield is drifting from the upper left
toward the lower right, creating a feeling of precariousness.

Roadway in Provence

1867–1870; *oil on canvas*; 35 7/8 x 28 in. (92.4 x 72.5 cm.).
Montreal, The Montreal Museum of Fine Arts.
Flat, encrusted patterns of paint characterize this scene
from near Cézanne's home in Provence. One of the
first large-format landscapes painted outdoors, the
influence of Corot and Courbet can be felt in the
contrast between the darker elements of nature and
the lighter tones of the blue sky and the ocher road.
Shortly before painting this work, Cézanne wrote to
Zola: "But, you know, all pictures done indoors, in the
studio, will never be as good as those done in the open."

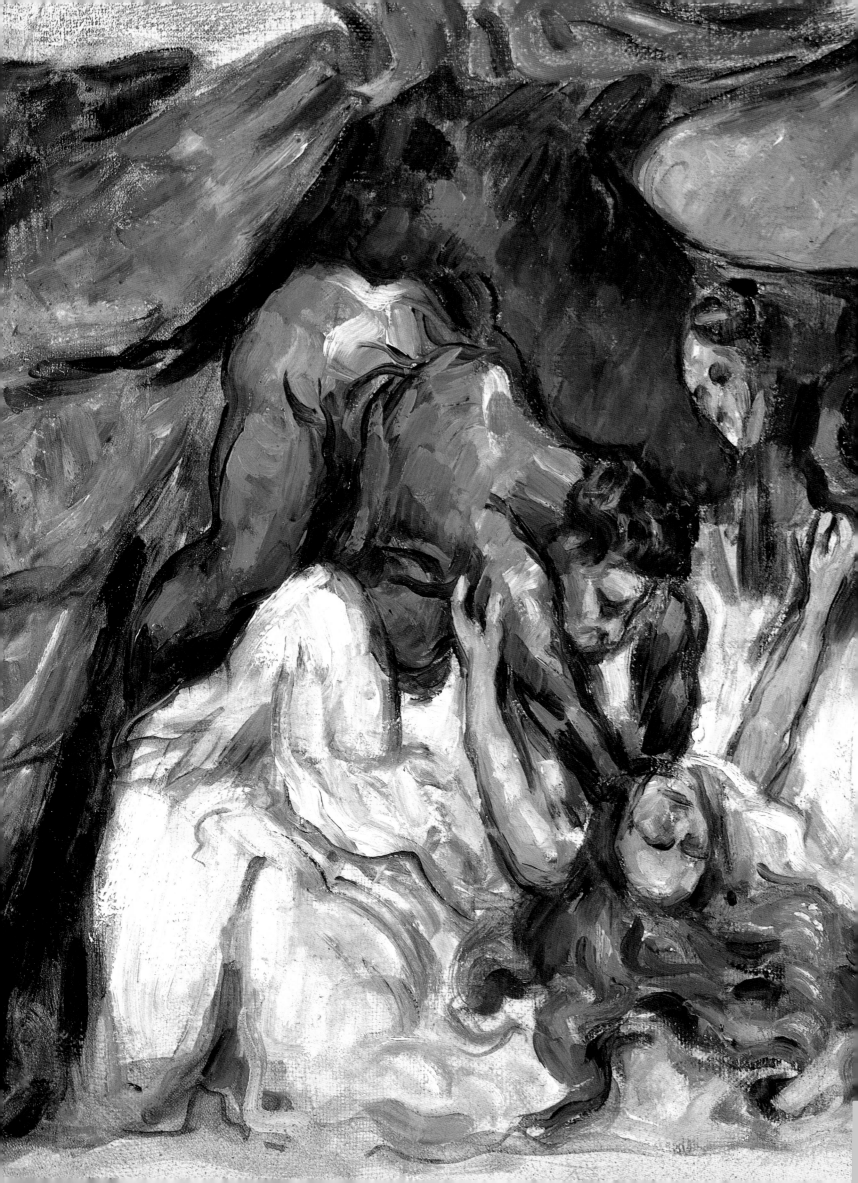

Landscape with Rocks

1870–1871; *oil on canvas;* 21 1/4 x 25 1/2 in. (53.8 x 64.9 cm.).
Frankfurt/Main, Staedtische Galerie im Staedelschen Kunstinstitut.
Opening himself to a direct, immediate approach toward nature, Cézanne depicted this scene with great attention to the effects of light and shadow. The rock formation to the right with its gray, beige, and white tones contrasts successfully with the dark-green pine trees. Diagonal streaks of shadows across the path alternate with sunlit areas, thus interrupting the movement into the distance. The forms are rendered with broad brushstrokes, typical of Cézanne's style during these years.

Strangled Woman

c. 1870–1872; *oil on canvas;* 12 1/4 x 10 in. (31 x 25 cm.).
Paris, Musée d'Orsay.
This work—which entered the museum in 1973 by donation—belongs to a series of paintings with dramatic, violent subjects. The work's emotional energy and fury matches the theme. It has been suggested that the pregnancy of Cézanne's mistress, Hortense, caused the artist anxiety which exacerbated his fears of sexuality and his revulsion against human contact. Zola quoted Cézanne as saying: "I don't need women, that would derange me too much. I don't know what's the use of it all, I've always been afraid of trying."

Still-life: Green Pot and Pewter Jug

c. 1870; oil on canvas;
24 3/4 x 31 1/2 in.
(64.5 x 81 cm.).
Paris, Musée d'Orsay.
*The utmost simplicity
with which Cézanne
arranged the humble
utensils of everyday life
has its precedents only
in still-life paintings by
Jean-Baptiste-Siméon
Chardin (1699–1779),
some of which he certain-
ly knew from his visits
to the Louvre. The items
are carefully assembled on
a board which appears to
be floating in space. The
green-glazed olive jar can
be found in various other
still-life paintings from
Cézanne's later periods.*

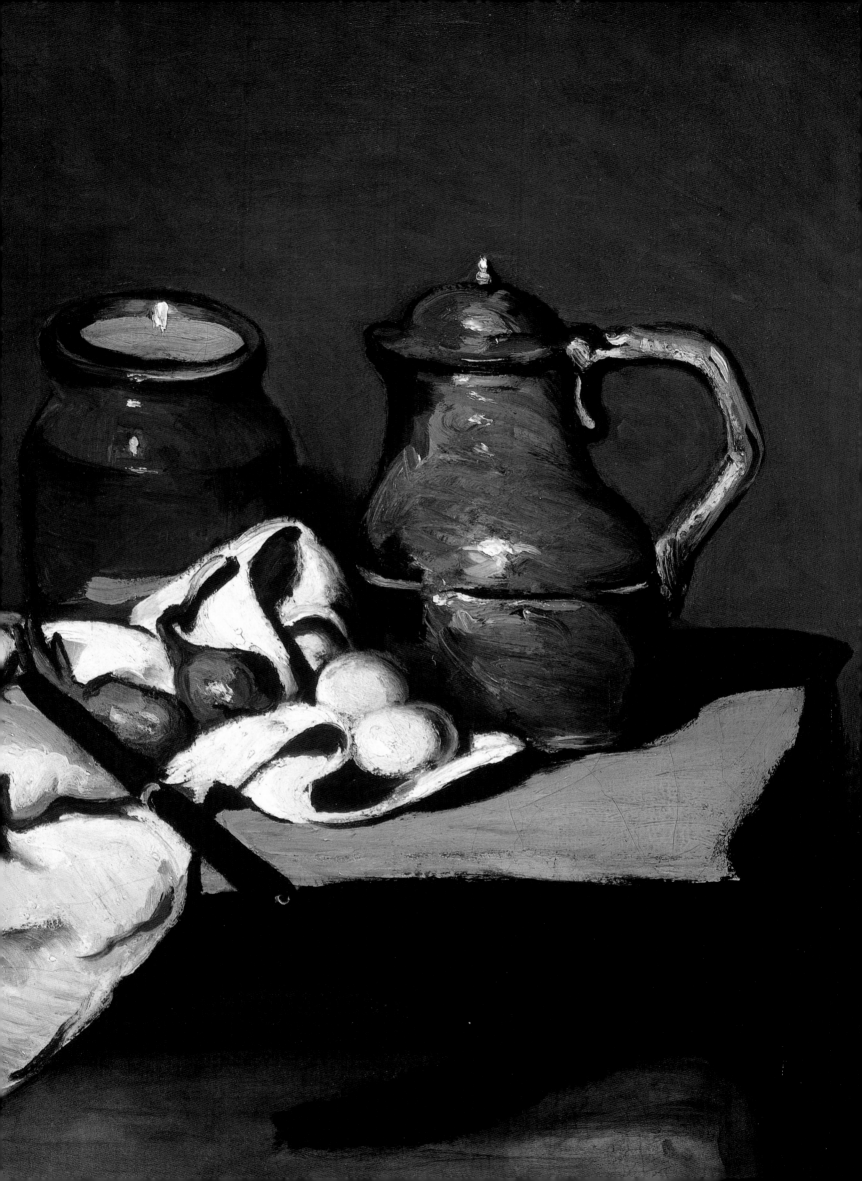

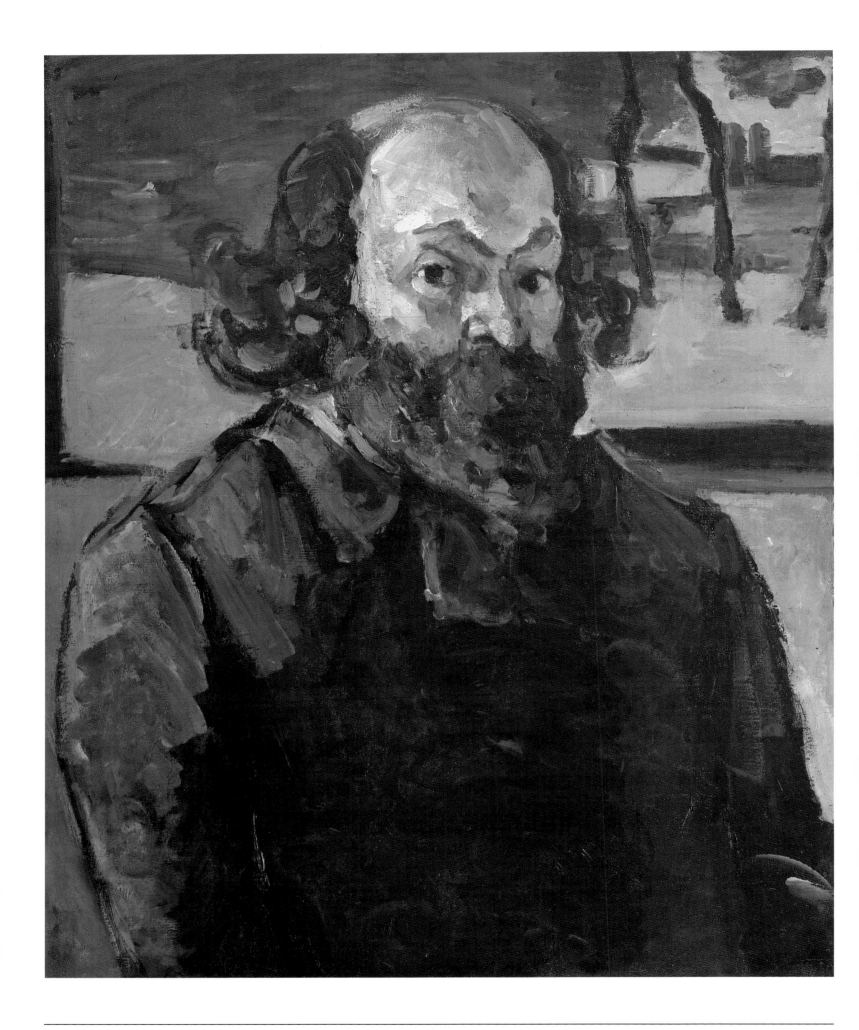

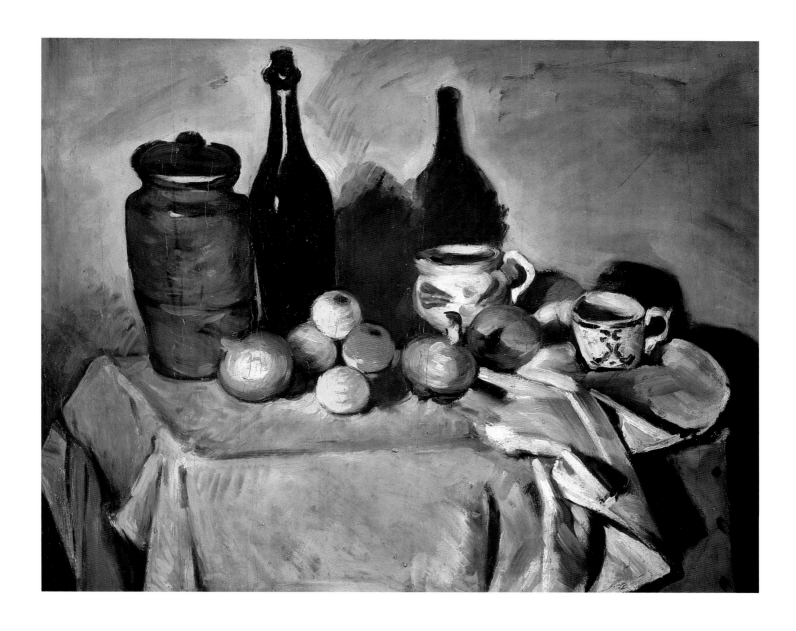

Self-portrait

1873–1876; *oil on canvas*; 25 1/4 x 20 1/2 in. (64 x 52 cm.).
Paris, Musée d'Orsay.
This self-portrait marks the end of a series of works reflecting the artist's emotional turmoil and struggle for an adequate artistic language. Cézanne's characteristic bald head and "revolutionary" beard are fully developed. His eyes and the fury of the work's execution reveal his impetuous temper. Probably in order to avoid the disturbing presence of his newborn son, the artist painted the work in the studio of his friend Armand Guillaumin, whose painting of the Seine with the distant Notre-Dame appears in the background.

Still-life: Pots, Bottle, Cup, and Fruit

c. 1871; *oil on canvas*; 25 1/8 x 31 1/2 in. (64 x 80 cm.).
Berlin, Staatliche Museen, Nationalgalerie.
Unusually brightly colored for such an early work, the present work shows the influence of paintings by the Impressionists, in particular those of Camille Pissarro. On a white tablecloth, which has been pulled back at the right in order to show the simply built table underneath, are displayed the green olive jar, the black bottle, the fruit, and the blue-and-white chinaware. The whitewashed wall in the back picks up the tonalities of the fabric.

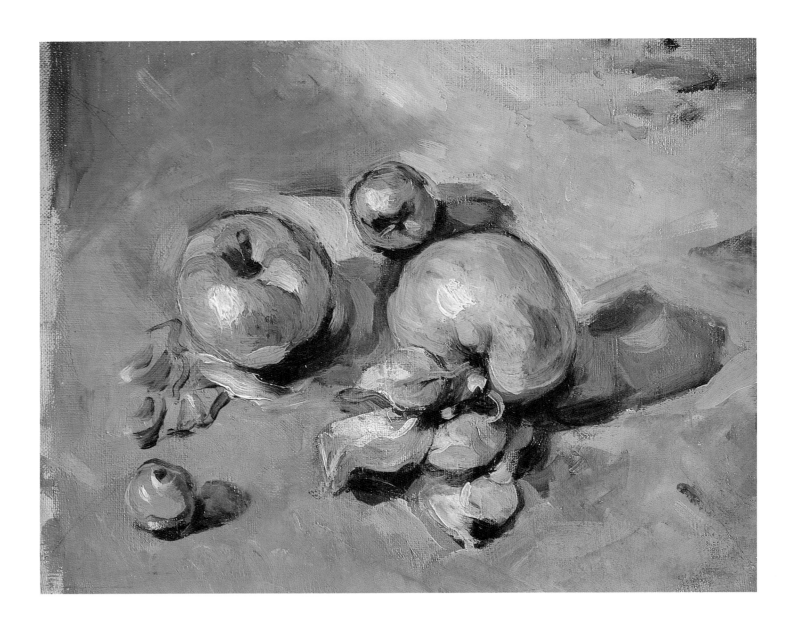

Green Apples

c. 1873; *oil on canvas*; 10 1/4 x 13 in. (26 x 32 cm.).
Paris, Musée d'Orsay.
In this small canvas painted during Cézanne's stay
in Auvers, one can still feel the tempestuous emotions
which agitated the previous figure compositions.
The brushwork is impulsive and choppy. Intense hues
of greens and yellows with luminous accents on the
fruit reveal, however, the influence of the Impressionists,
in particular that of the artist's friend Camille
Pissarro. The painting's first owner was Doctor
Gachet, mentor and patron of many young artists.

Dahlias

c. 1873–1875; *oil on canvas*; 28 3/4 x 21 1/4 in. (73 x 54 cm.).
Paris, Musée d'Orsay.
This still-life was painted in Auvers in the house of
Dr. Paul Gachet. There the Cézanne scholar Lionello
Venturi found the same blue delft vase, which had served
in a painting by Camille Pissarro as well. The flowers
probably came from Gachet's own garden, which Vincent
van Gogh would go on to celebrate less than twenty years
later in his own works. Although painted with short,
Impressionistic brushstrokes which capture the effects of
light, the objects have retained their weight and substance.

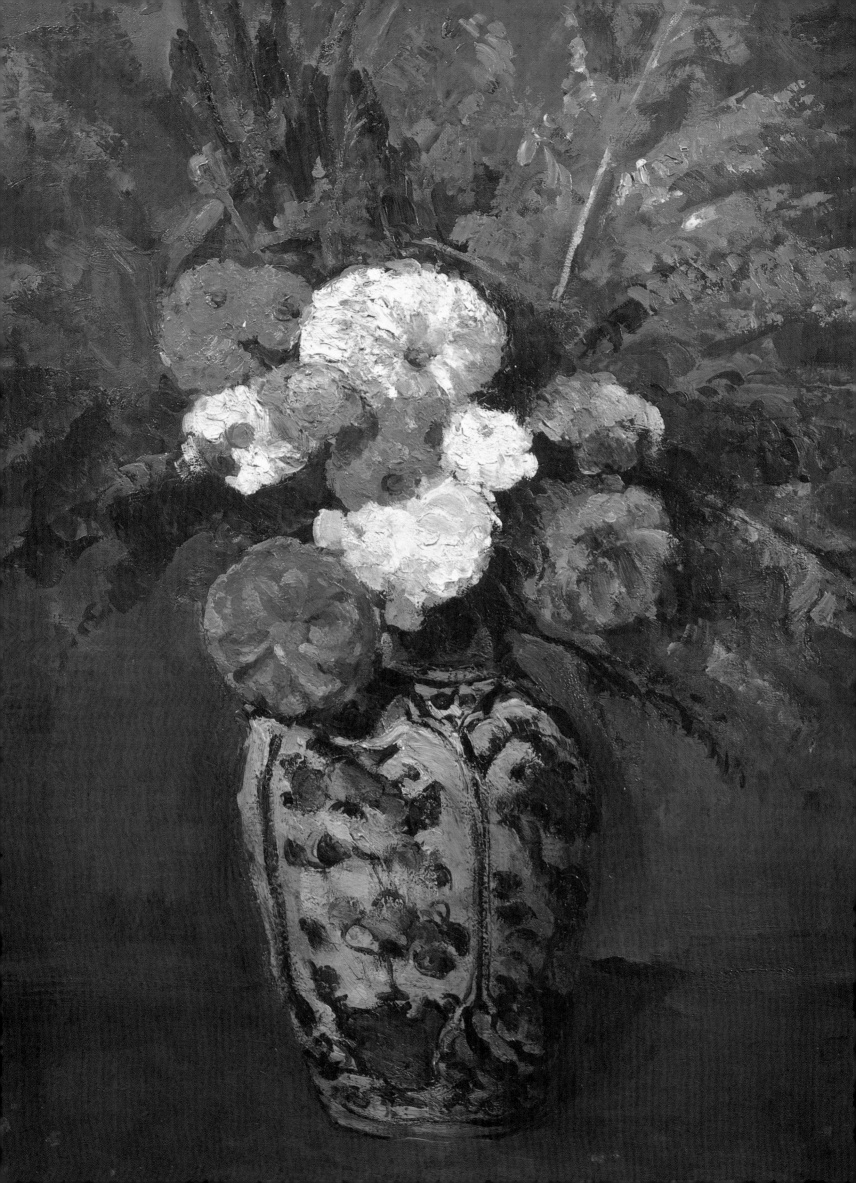

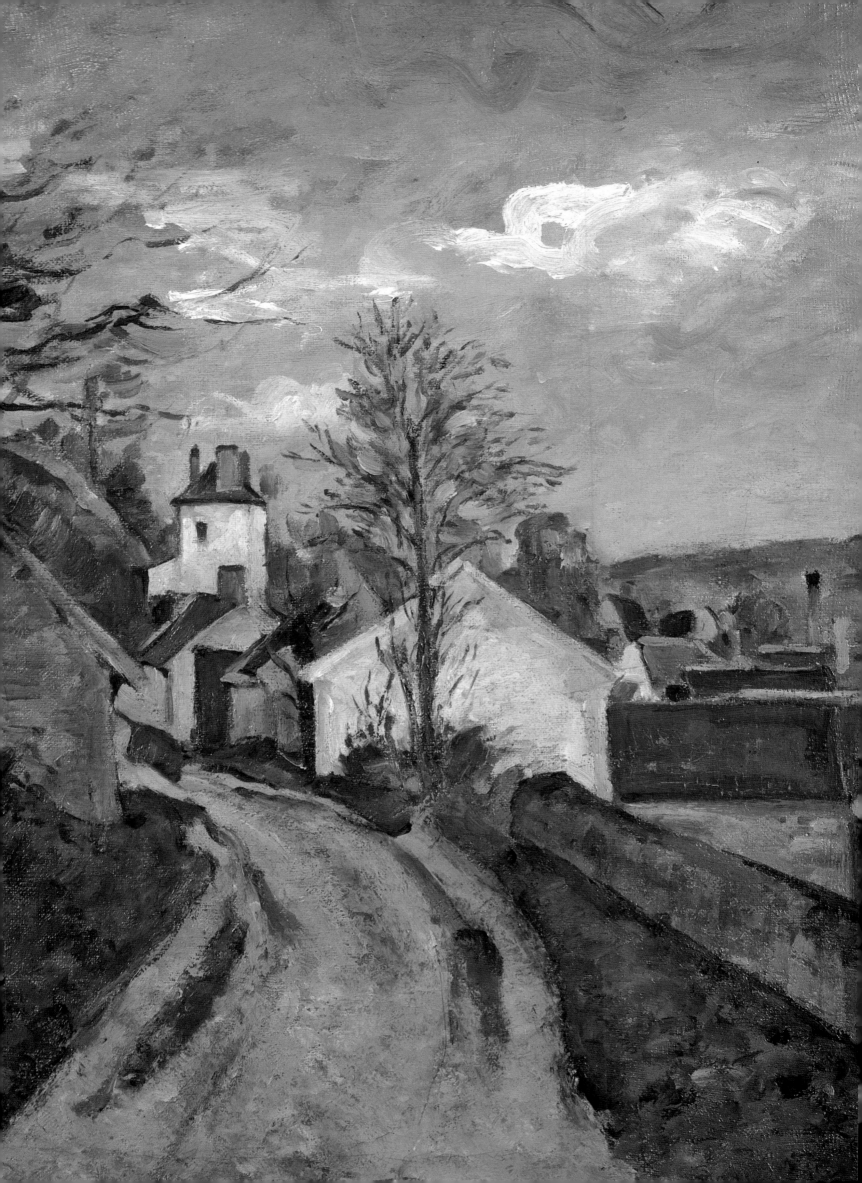

CHAPTER 2

LANDSCAPE PAINTING

Though art-historical categories are generic, they can be helpful to sort the existing material and allow an overview of an artist's stylistic developments. Thus, for example, Cézanne's works have been divided into four broad groups within which each work shares more or less common features. The early so-called romantic phase, which lasted from the late 1850s up to around 1872, was, as we have seen, characterized by a strong, personal emotional language. The second period began with Cézanne's move to Pontoise and Auvers, where he worked in a style similar to that of Pissarro and other Impressionists without ever making their idioms his own. Indeed, as we shall see, he always remained true to his own artistic concepts. This phase ended with Cézanne's withdrawal from the Impressionists' group shows after their unsuccessful third exhibition in 1877. In a letter to Octave Maus of November 25, 1889, Cézanne expressed, in retrospect, his intentions: "I had decided to work in silence until the day I felt capable of defending the theory of the results of my studies." However, it was through his paintings alone that he achieved the goal of expressing his theoretical approach.

This third period, which has been labeled constructive because of the artist's thorough method of carefully "constructing" his compositions, lasted until the late 1880s. After his marriage to Hortense Fiquet and the death of his father in 1886, Cézanne retired more often to his hometown in Aix, where he summed up his experiences in the final—what is termed synthetic—style. The subjects of the last two decades of his life portray a concern with the Provençal landscape and its people, in particular its peasants. These works are discussed in the last chapter.

Out-of-doors

First, during the involuntary sojourn at L'Estaque in 1870–1871, and then following the stay at Pontoise and Auvers between 1872 and 1874, Cézanne became convinced of his potential as a landscape artist. Since his childhood he had loved walking through the fields and hiking in the mountains, but during the first decade or so of his career as an artist he had aspired only to be a figure painter. The change was due to his close contact with Pissarro, who took to painting out-of-doors as the most natural way to work.

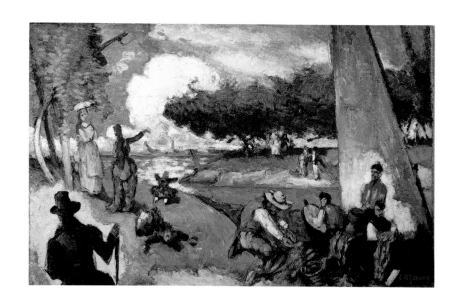

The House of Doctor Gachet in Auvers

c. 1873; *oil on canvas*; 18 1/8 x 14 3/4 in. (46 x 37.5 cm.). Paris, Musée d'Orsay.
Influenced by Camille Pissarro, Cézanne moved in 1872 first to Pontoise, then to Auvers, where the two artists often worked side by side. Rapidly, Cézanne's early style, with its dark colors and violent subjects, gave way to an Impressionistic technique that favored brighter hues. His landscapes differ, however, from those of his friend Pissarro as they show only rarely any signs of life. The road outside the house of Doctor Gachet, himself an amateur artist who became an ardent supporter of the Impressionists, is empty.

Scène Fantastique

c. 1875; *oil on canvas*; 26 x 32 in. (66 x 81.3 cm.). Private Collection
The Impressionistic qualities of this painting still cannot conceal its differences from the works of Pissarro, Monet, or Renoir. Although the colors have become much brighter, the subject is still rendered somewhat heavy-handedly. Figures stroll on the meadows along a canal or river, where fishermen are at work outside their sailing boat. A black figure with top hat, seen from the back at the left, stands probably for the artist himself. The only other figure that seems to take notice of him is the man in red on the boat. His role remains elusive, however.

An early example of Cézanne's out-of-doors painting is *The Railway Cut* (c. 1870), a view of the railway line and Mont Sainte-Victoire seen from the garden of Jas de Bouffan. This painting reveals elements of Cézanne's artistic development to come. Utterly economical, blocklike forms of a fragment of the real world are built up into a structural unity by a correspondingly limited range of colors. Behind the yellow, brown, and green strokes representing the grounds of the family mansion, plain streaks of a darker brown showing a barely recognizable garden wall separate the enclosed foreground from the outside world. On the hill to the left a cottage with its vermilion roof balances the weight of the blue mountain in the right. The scar in the hill, rendered with a deep India red and dark green, is the result of the construction of the railway line between Aix and Rognac. Although Cézanne used the relatively new system of mass transportation many times himself, he always remained wary of the change and destruction of his beloved Provençal landscape. Except for the inclusion of a few viaducts or railway buildings, he never alluded in his paintings to the rapid technological development which took place during his lifetime. And, unlike Impressionist painters such as Monet, he did not paint the trains themselves nor the effects of the clouds of steam puffed out by the engines.

The compelling simplicity and bulky weight of *The Railway Cut* were eventually replaced, persistently through the years, by a greater diversity of color, evoked by the multitude of configurations found in nature. It was precisely this sheer endless variety of nature's phenomena to which Cézanne committed himself for the rest of his life.

Painting directly from nature was a crucial topic during the discussions among the artists at the Café Guerbois, above all for Monet and Renoir, who had painted together in 1869 at the bathing resort "La Grenouillère" outside of Paris, thereby virtually inaugurating the Impressionist style. But Cézanne never adopted any of the more precise, refined systems of Impressionist-style painting, and he clearly distinguished himself from the almost scientific formula of post-Impressionist pointillism as developed during the mid 1880s. Instead, he gave up the palette-knife style and broad brush-curls, and moved toward a method of fine, long parallel strokes, which were applied in layer upon layer of transparent color. At first the strokes run in more or less the same direction over the whole canvas; only after he had mastered the definition of planes did the artist achieve a variety of levels by treating various areas individually. Cézanne thus developed his patterns of color patches, each of which is clearly distinct from its neighboring fields both by range of color as well as

**The Avenue at the
Jas de Bouffan**

c. 1874–1875; *oil on canvas;*
15 x 18 1/8 in. (38.1 x 46 cm.).
London, The Tate Gallery.
*This painting is the first in
a series depicting the beloved
chestnut trees at Jas de
Bouffan, the Cézanne
family's residence since 1859.
A precise date for this work
is difficult to ascertain,
however. The picture surface
consists of a series of parallel
zones with a steep recession
into the shadowed alley. The
compressed space, heavy forms,
and diagonal planes of foliage
mark the beginning of a style
which later became very char-
acteristic of the artist's oeuvre.*

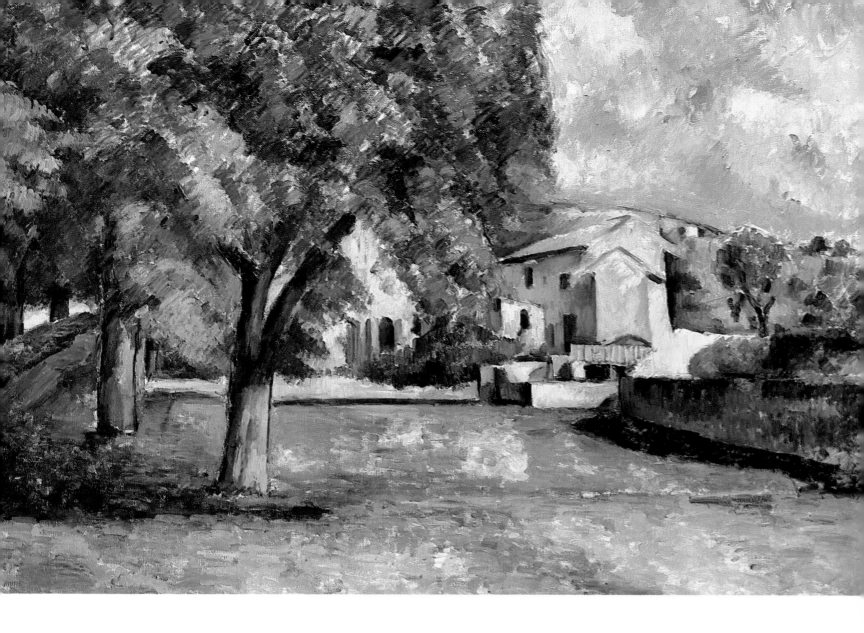

direction of brushwork. As a result he was able to represent a rich diversity of planes and movements in space without losing any brilliance of color and its reflections.

Yet Cézanne still had a long way to go before he could enjoy the full achievements of his art. Over the next thirty years or so he worked with dedication toward this aim. The final results of these intense efforts are the views of the Mont Sainte-Victoire painted during his last years.

Faithful Landscapes

From Pissarro Cézanne learned to brighten his palette toward richer, more brilliant hues. "Never paint except with the three primary colors [red, blue, yellow] and their immediate derivatives," Pissarro explained. He himself had already eliminated from his palette black, bitumen, burnt sienna, and the ochers. As a result, gradually the masses of volumes began to lose their opacity and yield to subtler interrelations of color without becoming vague or ambiguous. In fact, their identity and form is intensified.

Cézanne began to gain control over the agitated conceptions of his imagination, replacing them with a faithful observation of nature via direct vision. *The House of Doctor Gachet in Auvers* and *The House of the Hanged Man* illustrate the process of change that had taken place in the artist's mind. In both works the blocks of forms are solidly defined and kept in balance by a careful arrangement of horizontals, verticals, and diagonals. Following Pissarro's suggestion, Cézanne got rid of his black outlines and the harsh isolation of objects or areas. But the continued use of thick layers of paint link this new style to his previous works. As is known from his own commentary, Cézanne strived to paint nature as he

Chestnut Trees and Farmhouse at Jas de Bouffan
1885–1887; *oil on canvas;*
28 3/4 x 36 1/4 in. (73 x 92 cm.).
Moscow, Pushkin Museum of Fine Arts.
The former residence of the governors of Provence was purchased by the painter's father in 1859 and became a rich source of motifs for the artist. Its Provençal name means "House of the Winds." Cézanne was particularly fond of the old chestnut trees in the park, which he painted in several canvases. After his mother's death in 1897, the estate was sold for unknown reasons, although it was perfectly within Cézanne's means to buy up the shares of his two sisters.

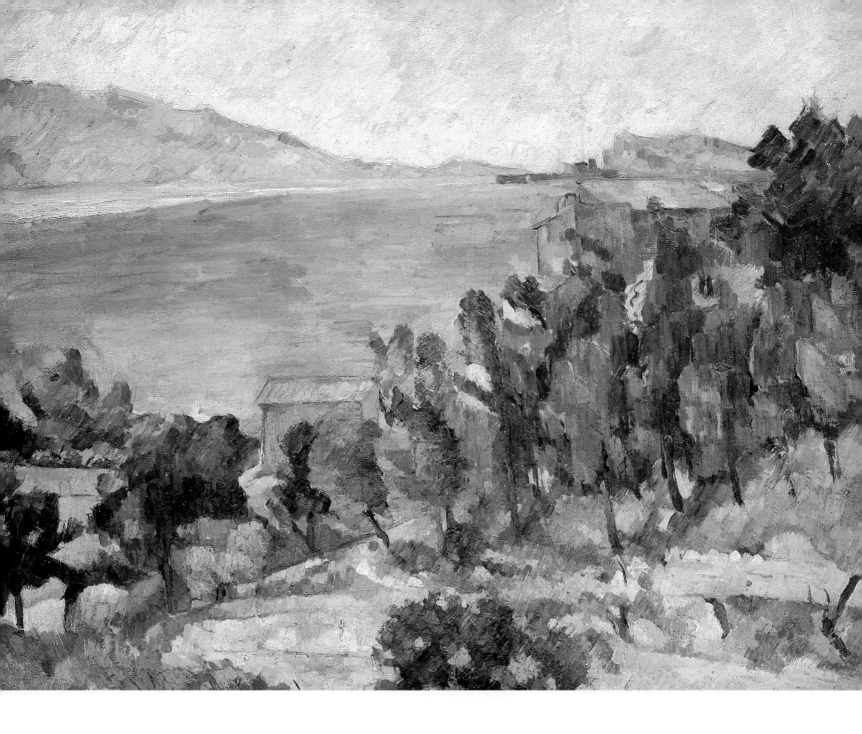

La Montagne Marseilleveyre and Ile Maire

1882–1885; *oil on canvas;* 20 x 24 1/2 in. (51 x 62 cm.). Saint-Prex, Private Collection. *For a slow-working painter like Cézanne, the Mediterranean landscape offered consistently favorable weather conditions and an almost unchanging vegetation. The harsh light, however, flattened the forms, a circumstance with which Cézanne's Impressionist painter friends had difficulties during their visits to the south. This work is divided into three distinct areas. In the foreground are portrayed the houses and vegetation; the bay of Marseilles is depicted in the middle-ground; and the Montagne Marseilleveyre and the Ile Maire lie in the distance.*

himself observed, as faithful to his own perception as he could. However, each time he added a stroke of paint to a small area, he felt it necessary to retouch others in order to regain the required balance. By applying numerous layers onto the canvas he achieved a granular patching rich in texture which resulted in an encrusted surface.

Although he respected the work and advice of Pissarro, Cézanne was never akin to his friend's socialist vision of peasants working harmoniously in a peaceful countryside. As a matter of fact, Cézanne's landscapes rarely show any sign of life at all. But he drew from Pissarro a liking for buildings seen up close with their large, plain forms. In *The House of Doctor Gachet in Auvers* the street is empty. A bending road—a motif that the artist was going to exploit a number of times in his works (for instance, in *Bending Road* and *Bending Road in the Provence*)—seems to be leading toward the house with its peculiar towerlike shape. The street and the diagonally running low wall provide a movement toward depth which is slowed down by the large white wall of the first house on the right.

The title of *The House of the Hanged Man* seems to hark back to Cézanne's macabre attitude of previous years and can be considered one of those "subjects with halos," as André Breton called such morbid romanticism. Many years after its execution this work was still on Cézanne's mind; he decided to exhibit it at the Exposition Universelle in 1889. The artist then implied that the romantic title had actually not

been his own. But the fact that he used the image of a hanged man as a personal emblem on an etching from that period, thereby identifying himself as the painter of this work, shows his continuing awareness of and affinity to its somber connotations.

Various lines of intersecting planes formed by the two roads and the roofs of the farm buildings come together where the street on the right hand leads into a kind of open square in front of the house. Its dark window and entrance door evoke the haunting sensations promised by the title. Although the brushwork offers an enriched play of light and shadow, the overall effect of the canvas breathes a solidity and firmness which clearly distinguishes this work from the results offered by Impressionist painters like Pissarro, Monet, or Renoir, whose dappled views of sunbathed landscapes dissolve the objects rather than stress their presence.

Cézanne's shift away from interior fantasies toward exterior perceptions was, he believed, so crucial that even in later years he would refer to himself respectfully as Pissarro's pupil. Probably nobody else but the generous and patient Camille Pissarro, whom Cézanne remembered as "the Good God," would have been able to bring this change about in such a determined man as Cézanne. By that time—that is, in 1872—Pissarro was over forty, and while Cézanne was himself thirty-three he was in many ways still quite an immature individual. It was largely through Pissarro's understanding of his younger colleague's fears and doubts that he was able to induce this growth and change.

Another source of support during his time at Auvers was Dr. Paul Gachet, a physician and amateur artist who became increasingly interested in homeopathy and who would go on to take care of Vincent van Gogh during the last months of his life. Dr. Gachet's large house, which Cézanne depicted, had a terraced garden full of flowers and plants. In Paris, Gachet frequented the Café Guerbois and came to know Manet, Monet, Renoir, Degas, among others. He was, possibly, the first to buy a couple of canvases from Cézanne and he offered him the use of the printing press in his house, with which Cézanne produced some of his few existing etchings.

Movement and Growth

After his departure from Auvers in 1874, Cézanne lived mostly in Paris and Aix, traveling frequently back and forth between the two geographical centers of his life. But he returned to Auvers and Pontoise toward the

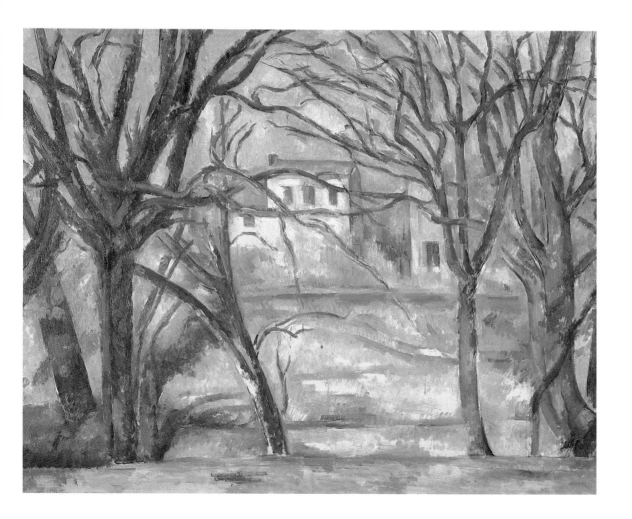

Houses and Trees
1885–1887; *oil on canvas*; 21 1/4 x 28 3/4 in. (54 x 73 cm.). Paris, Musée de l'Orangerie. *Cézanne frequently arranged dark-trunked trees in the foreground set off against a light-colored landscape in the background. Here the lines of the trees and the buildings in the distance appear parallel to the canvas without any curve or diagonal that might have suggested depth. Only the contrast of coloristic value defines the space. The painting probably depicts a house located near Tholonet, between Aix-en-Provence and the Mont Sainte-Victoire.*

end of the decade, when he painted *Farmyard at Auvers*, putatively executed between 1879 and 1882. The lack of precise dates for Cézanne's works is mostly due to the artist's slow working process. Often his paintings progressed over months or years, unlike the works of most Impressionists such as Renoir or even Monet, who most often responded immediately to given subjects or situations, thus hoping to retain spontaneity and liveliness in their renderings. Cézanne's subjects appear therefore at times impersonal and distanced, just as his earlier paintings had been fraught with explosions of personal emotions.

From his renewed stay with Pissarro at Pontoise in 1881 dates *Mill on the Couleuvre near Pontoise*. The degree of maturity to which Cézanne had reached over the past decade is striking. This composition is clearly structured in tectonic forms; regular brushstrokes define the various elements with a fresh and light palette offering a wide gamut of greens, blues, and ochers. By then the roles of Cézanne as student and Pissarro as teacher had at least been equaled, if not reversed. In a letter of 1895 written to his son Lucien, Pissarro acknowledged that the two artists had constantly exchanged their experience and that each had benefited from the other.

By that time, Cézanne had developed a technique which superficially resembled the dappling of the Impressionists but which was very much his own device. Numerous parallel brushstrokes, short yet fairly broad and vigorous, cover the canvas like a web, defining the objects by the mere interplay of the different tonalities of adjacent color fields. One of the most felicitous paintings of this period is *The Bridge at Maincy, near Melun* (c. 1879–80), where he applied the same technique throughout the canvas, regardless of the difference in texture of the represented object. The foliage of the trees, the still surface of the water, and the stone and wood with which the bridge has been built are all defined by the same style of regular brushwork, while differentiation of the surface texture is achieved by use of various colors only. An even more uniform painterly treatment of the canvas can be found in *The Poplars* (c. 1879–82), in which the trees are rendered with the same regular hatching. Only the trunks, the grass, and the sky are rendered in a more cursory way.

This approach allowed for a solid composition, wherein each element has its firm place. These are not "impressions," quick and spontaneous renderings that attempt to catch the effects of flickering light as reflected by the objects. In fact, Cézanne was never interested in that aspect of out-of-door painting. He favored structure over individual subjective sensations, as he felt that he could not realize his vision without an organization of lines and colors that gave stability and

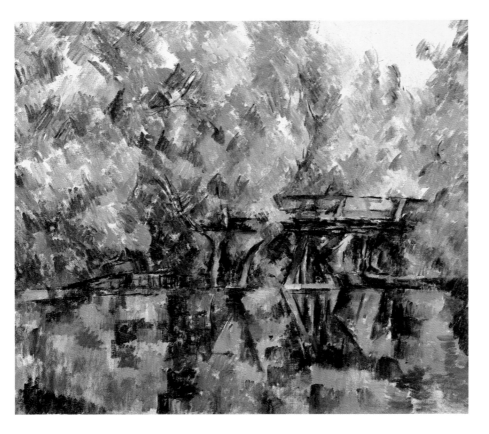

Bridge over a Swamp

1888–1890; *oil on canvas*; 25 1/4 x 31 in. (64 x 79 cm.). Moscow, Pushkin Museum of Fine Arts.

This painting is stylistically connected to Embankments of the Marne River, *painted around the same time. Various shades of green build up the landscape, with the gray canvas shining through the thin layers of paint. At the center of the composition a small bridge, painted in warm brown tones, spans a swamp or a pond. Typical of Cézanne are the parallel brushstrokes, whose direction changes in each color patch.*

The Aqueduct

1885–1887; *oil on canvas*; 35 3/4 x 28 1/3 in. (91 x 72 cm.). Moscow, Pushkin Museum of Fine Arts.

Between 1885 and 1887, Cézanne painted several views of the Arc river valley with the mountain range of Mont Sainte-Victoire in the distance. In the present depiction a group of pine trees in the center forms a vertical axis that organizes the entire pictorial space. The canvas is characterized by a vertical movement, emphasized by the painting's format and the color range, starting with warm ocher hues in the foreground to the deep greens of the trees and the cold blues of the mountains and cloudless sky in the distance.

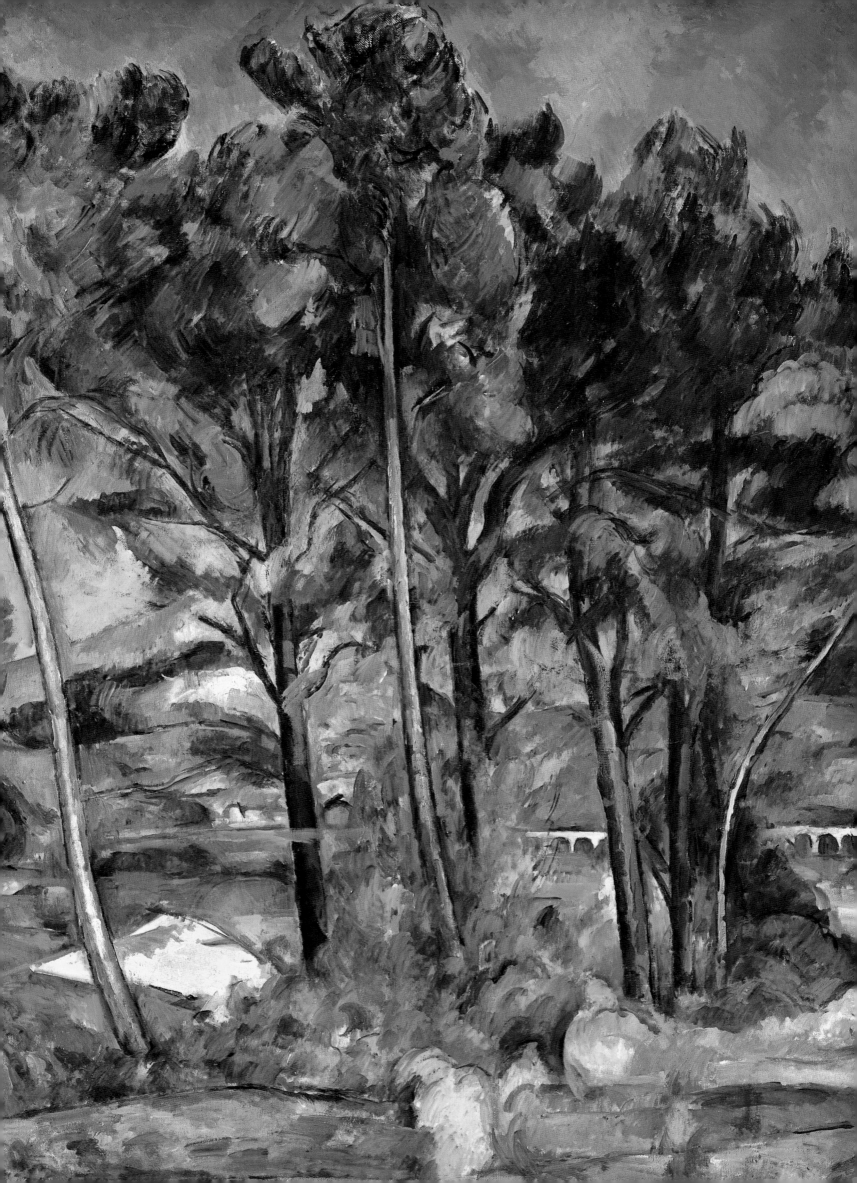

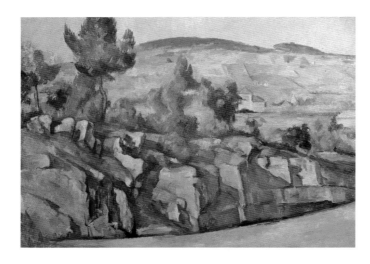

Mountains in Provence

1886–1890; *oil on canvas*; 25 x 31 1/4 in. (63.5 x 79.4 cm.).
London, National Gallery.

The volume of the geometric shapes of the rocks are echoed by the pattern of the fields on the slope in the background. The two planes are divided by a group of trees and shrubs painted with clearly visible parallel brushstrokes. They add a greater liveliness to the scene, thus giving the impression that a strong wind is blowing. The neutral foreground serves as a calm point of departure for the eye.

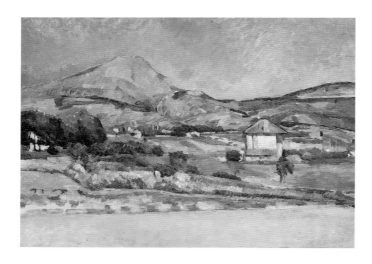

Landscape with La Montagne Sainte-Victoire

c. 1882–1885; *oil on canvas*; 22 3/4 x 28 1/3 in. (58 x 72 cm.).
Moscow, Pushkin Museum of Fine Arts.

Leaving behind his Impressionist phase, Cézanne began to explore in paintings like this one the principle of clear-cut planes, with the well-designated texture and volume of individual components of the landscape. In later works of the same subject he was to perfect this style. However, its basic elements as well as the color scheme with its characteristic deep blues, oranges, and greens is here already present.

clarity to the image on the canvas. His aim was to produce work which equaled the art of the great masters of the past. The monumental and enduring quality of their works was the rule with which he measured his own achievement. His objective was to paint like "a living Poussin in the open air, with color and light, instead of one of those works created in a studio, where everything has the brown coloring of feeble daylight without reflections from the sky."

Landscapes at Midi

Although Cézanne painted repeatedly the northern landscapes around Paris, especially during his stays in the late 1880s, he was clearly more at ease with the warm, arid climate of the Midi near Aix and at L'Estaque. During his intermittent stays with his parents at the Jas de Bouffan he painted numerous views of the grounds of the family estate. *Chestnut Trees and Farmhouse at Jas de Bouffan* and *The Avenue at the Jas de Bouffan* are two renderings of preferred corners there. Yet another is portrayed in *The Pond at Jas de Bouffan*. While the last two works, which date from around the mid-1870s, are subdued in their color harmonies, *Chestnut Trees and Farmhouse* is clearly richer in tonalities and offers a wider range of brushwork and compositional devices. It dates from the mid-1880s.

By that time Cézanne had also been visiting regularly L'Estaque on the Mediterranean, where he had sought refuge during the Franco-Prussian war. Here he recovered from the strains of Parisian life as well as from the suffocating situation at his parents' home. The panoramic views across the bay of Marseilles, with its deep blue water, especially caught his attention: "The whole, toward evening, had a very decorative effect," he reported. At times he stayed overnight in a flat in Marseilles, leaving early in the morning for day trips to nearby L'Estaque. On other occasions he rented a small house with a garden, just above the train station.

In the summer of 1876, while working at L'Estaque on two views of the Mediterranean for the collector

The Bibémus Quarry

1898–1900; *oil on canvas*; 25 5/8 x 21 1/4 in. (65 x 54 cm.).
New York, Collection Sam Spiegel.

Entangled forms of ochers and greens culminate in the presence of a small pine tree whose umbrella reaches into the pale sky. At the bottom a triangular-shaped form of deep ocher points toward a light spot at the center of the composition. The execution, with heavily painted brushstrokes, shows Cézanne's great assurance in conveying the relationship of forms and strong colors which particularly attracted him to this lonely site.

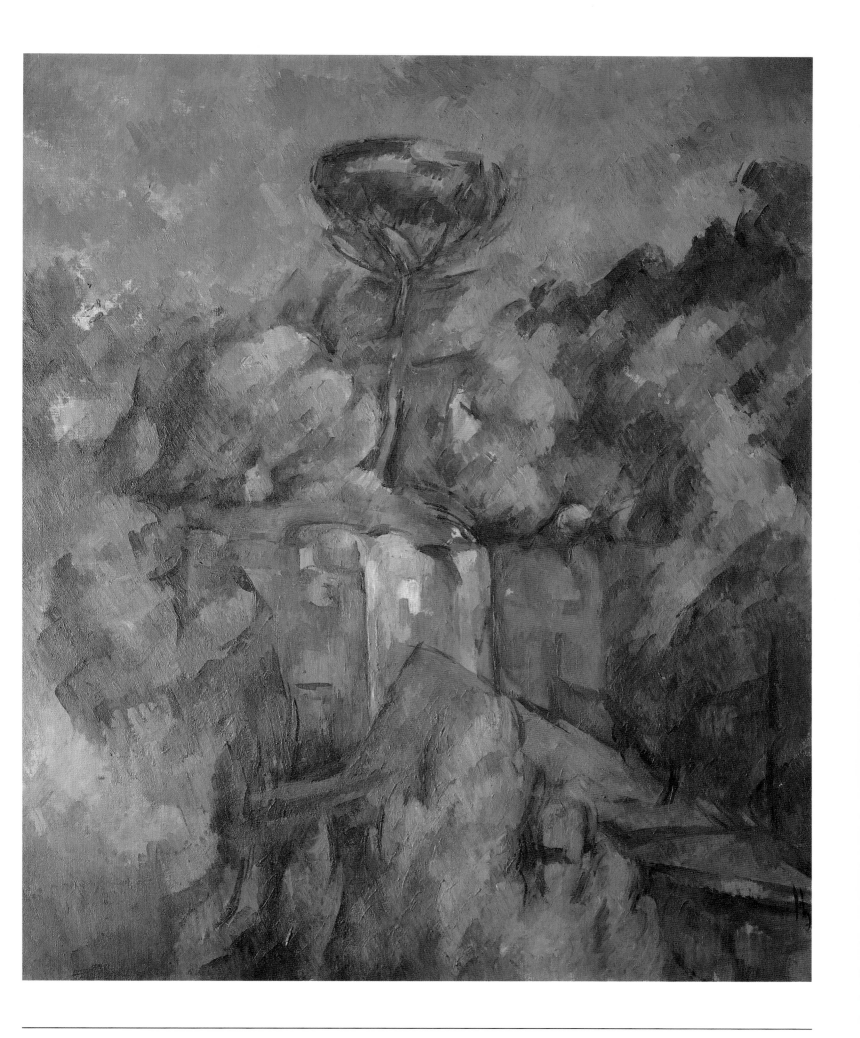

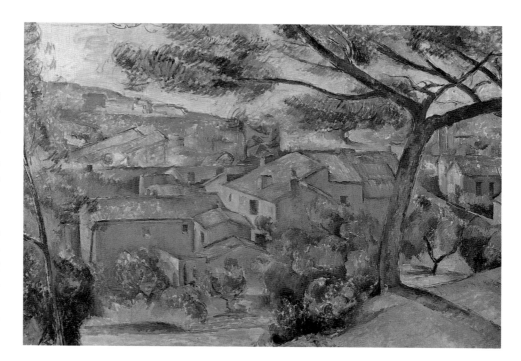

Morning View of L'Estaque

1882–1883; *oil on canvas;*
23 3/4 x 36 1/2 in. (60.5 x 92.5 cm.).
Jerusalem, Israel Museum, Gallery of Modern Art.
Compared to The Sea near L'Estaque *from 1878–79 Cézanne has here achieved a greater unity between the various parts of the landscape. The slope descends without rupture down toward the houses, which form an intricate pattern with their roofs and walls. Shrubs allow for a smooth transition from the foreground to the middleground. At L'Estaque Cézanne enjoyed particularly the evening hours when he would often climb up the hills to watch the panorama of the sunset over the bay of Marseilles.*

Turn in the Road

c. 1881; *oil on canvas;* 23 3/4 x 29 in. (60.5 x 73.5 cm.).
Boston, Museum of Fine Arts.
A bending road flanked by garden walls describes a semicircle behind which tightly fitted farm buildings appear among the trees. The artist's indifference with regard to a correct rendering by use of linear perspective is obvious. The road ends abruptly in the middleground, and the entangled roofs are seen from a number of different viewpoints. Space is defined by crossing vertical and horizontal lines as well as by color relationships. This work once belonged to Claude Monet, who owned thirteen of Cézanne's canvases.

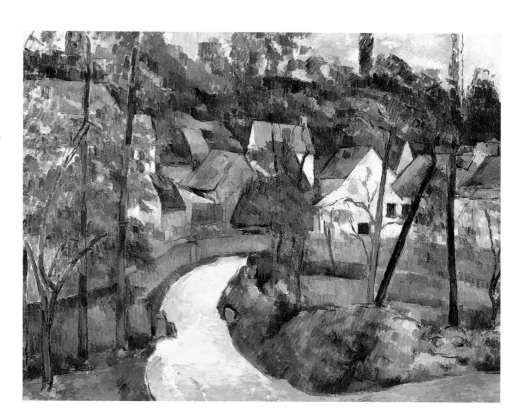

The Pool at Jas de Bouffan

c. 1878–1889; *oil on canvas;*
29 x 23 3/4 in. (73.5 x 60.5 cm.).
Buffalo, New York, Albright-Knox Art Gallery.
The pond in the park of Jas de Bouffan, the family's mansion in Aix, became a frequent motif in Cézanne's oeuvre. The chestnut trees are reflected in the surface of the water, which is thus linked to the angular fields of grass in the foreground and in the distance. The leaves of the trees are painted with parallel oblique brushstrokes while the water and the surrounding stone walls are rendered with horizontal patches of color.

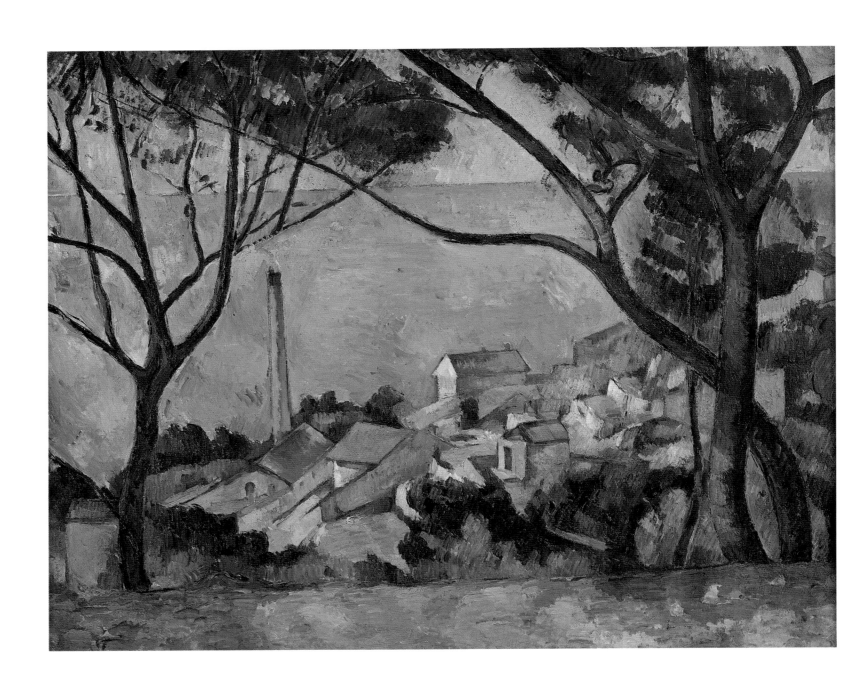

The Sea near L'Estaque

1878–1879; *oil on canvas*; 28 3/4 x 36 1/4 in. (73 x 92 cm.). Paris, Musée Picasso.

Between July 1878 and March 1879 Cézanne worked on the Mediterranean coast at L'Estaque near Marseilles. Seen from a path on the hills, the view runs down between two framing pine trees over the red and purple roofs of the village toward the blue-green sea. A chimney balances the horizontal and vertical movements of the picture. The landscape with its various elements is still lacking a harmonious unity, which Cézanne would eventually fully achieve in later works beginning in the 1880s.

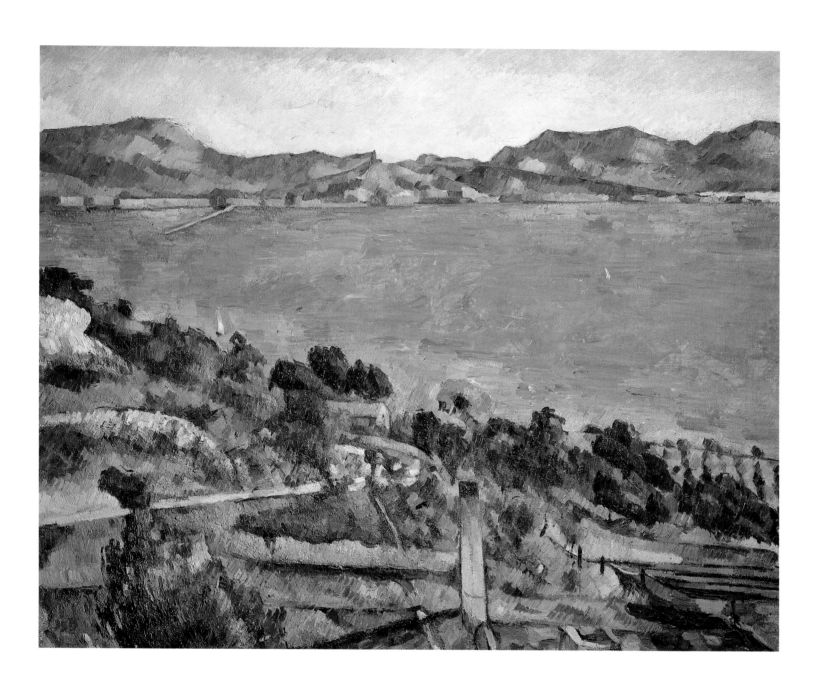

L'Estaque on the Gulf of Marseilles

c. 1882–1885; *oil on canvas*; 22 3/4 x 28 1/3 in. (58 x 72 cm.). Paris, Musée d'Orsay.

In a letter to Camille Pissarro written from L'Estaque in July 1876 Cézanne praised the landscape he found there: "[Here] it is like a playing card, red roofs against the blue sea. . . . Motifs can be found here which would require three or four months' work, and that is possible because the vegetation doesn't change. It is composed of olive and pine trees which always preserve their foliage. The sun is so terrific that it seems to me as if the objects were silhouetted not only in black and white, but in blue, red, brown, and violet. I may be mistaken, but this seems to me to be the opposite of modeling."

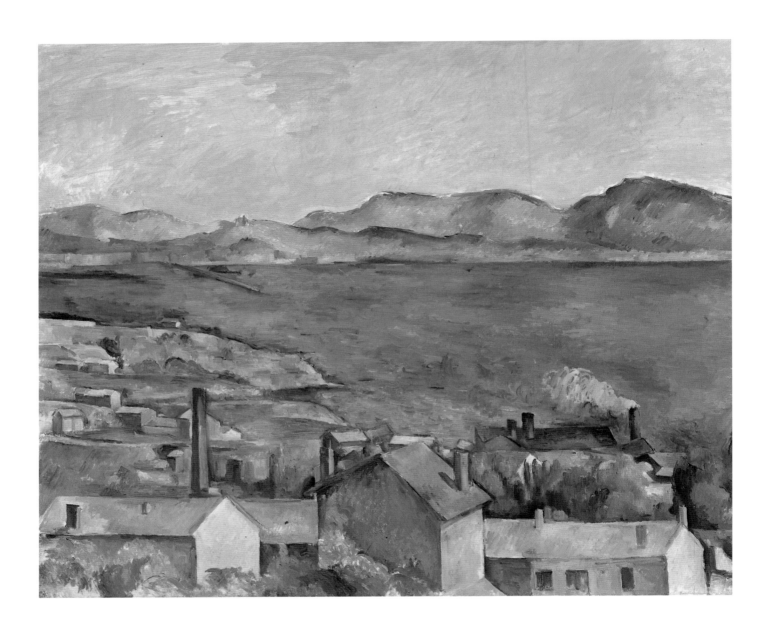

The Bay of Marseilles, seen from L'Estaque
c. 1886–1890; *oil on canvas*; 31 3/4 x 39 1/4 in. (80.8 x 99.8 cm.).
Chicago, The Art Institute.
This view over the bay of Marseilles is divided into four horizontal layers. In the foreground lies the village of L'Estaque, which Cézanne visited frequently in the 1870s and 1880s, with its vibrant orange and green hues; the dark-blue Mediterranean Sea is portrayed behind the village; the light-blue mountains rest on the far shore; and the soft washes of the sky lie atop it all. The chimney on the left takes up the vertical color development, and the protruding jetty across the bay serves as a link between the various elements.

Alley at Chantilly
1888; *oil on canvas*; 32 1/4 x 26 in. (82 x 66 cm.).
London, National Gallery, Berggruen Collection.
In 1888 Cézanne spent about five months at the Hôtel Delacourt in Chantilly, about one hour by train northeast of Paris. The present canvas is one of a few works that document this stay. The alley, rendered with an almost abstract pattern of greens and ochers, ends in a light-yellow and green clearing. Few horizontal lines slow down the suction into the distance, while a mosaic of regularly applied brushstrokes defines the space. A barely defined flickering light penetrates the dense foliage.

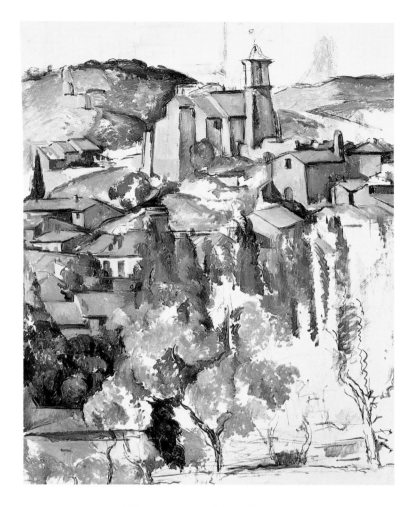

The Village of Gardanne
c. 1885–1887; *oil on canvas*; 36 1/4 x 29 1/3 in. (92 x 74.6 cm.).
New York, The Brooklyn Museum.
*Before his marriage to Hortense Fiquet in April 1886 and his subse-
quent reconciliation with his father, Cézanne lived for some time in the
village of Gardanne, near Aix. In this unfinished canvas the warm-
colored buildings with their yellows, oranges, and reds emerge from the
blue-green patches of the foliage around them. The pyramidal structure
of the composition is crowned by the local church and its bell tower.*

Pine Tree and Red Soil
c. 1895; *oil on canvas*; 28 3/4 x 36 1/4 in. (73 x 92 cm.).
St. Petersburg, Hermitage.
*The foreground is closed on all four sides by shrubs and the
large umbrella of a pine tree, which stood near the Bellevue
mansion of Cézanne's sister Rose. The sun-filled plain of the
Arc valley in the background is only partially visible, while
the dark green, blue-black, and purple of the tree together
with the deep-red earth dominate the coloristic field.*

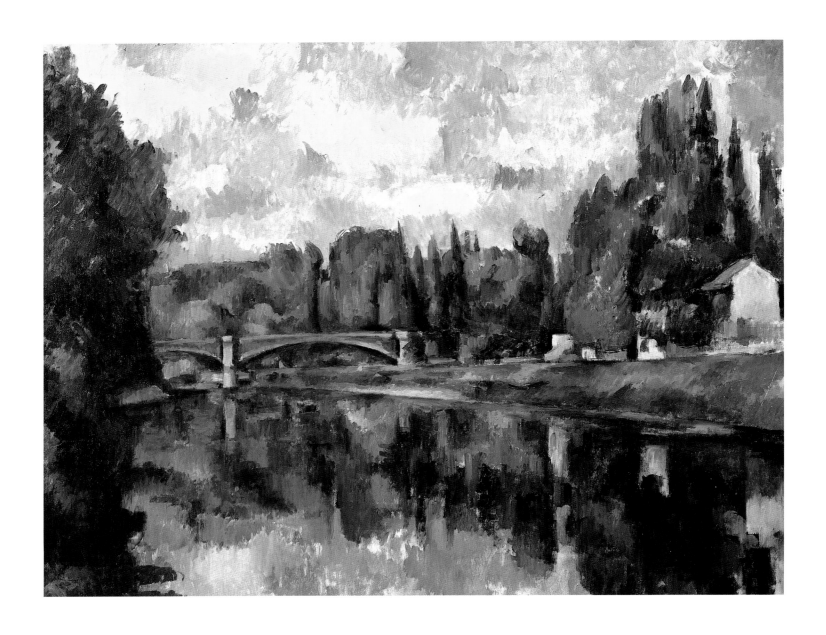

Bridge over the Marne at Créteil
1888; *oil on canvas*; 28 x 35 1/2 in. (71 x 90 cm.).
Moscow, Pushkin Museum of Fine Arts.
River landscapes and bridges are a common motif
in Cézanne's oeuvre. While living in Paris, he
frequently made trips into the region surrounding
the city, painting among other scenes several views
of the Marne River. The embankment on the
right leads diagonally into the distance where a
double-parted bridge spans the water reflecting
trees, buildings, and the sky on its calm surface.

Country House by the Water
c. 1888–1890; *oil on canvas*; 32 x 25 1/2 in. (81 x 65 cm.).
Jerusalem, Israel Museum, Gallery of Modern Art.
This view of a house along a river, possibly a water mill, was
painted in the vicinity of Paris. It demonstrates Cézanne's
skills as a landscape artist who has developed an extraordinary
sensitivity for nature. Squeezed in between two tall trees, the
house amplifies its presence into the expanded foreground by its
reflection on the water, thus adding depth to the depicted scene.

CHAPTER 3

PORTRAITS, ALLEGORIES, STILL-LIFES

oday Cézanne is best known to the public for his landscape and still-life paintings, although the artist himself admired figure painting as a higher art form. He actually began his career as a figure painter but under the influence of Pissarro and Impressionism he turned toward painting landscapes. Then in his late-period bather series he attempted to combine figure and landscape painting in the tradition of the Old Masters he had studied so ardently in the Louvre.

Portraiture Method

Many of Cézanne's important portraits and figure paintings date from the 1880s and 1890s. Often he used himself as a model, and there exist more than twenty self-portraits by the artist. Only van Gogh perhaps was as equally obsessed with painting his own likeness. One reason for this is that the artist himself is of course his least expensive model, and until his father's death in 1886 Cézanne was invariably short of money because his monthly allowance was rather meager. Additionally, in his case, it was difficult to find sitters who were patient enough to sit motionless for hours during countless sessions. There is a picturesque description of the artist at work by Cézanne's dealer Ambroise Vollard, who in 1899 posed for his portrait. The sittings began at eight in the morning and lasted until eleven-thirty. During these hours the sitter was not only forbidden to move but he also had to remain silent, and there were but short rest periods. In the afternoons, Cézanne frequently went to the Louvre to study the works of the masters in order

Mardi Gras (Pierrot and Harlequin)

1888; *oil on canvas*; 40 1/4 x 31 3/4 in. (102 x 81 cm.).
Moscow, Pushkin Museum of Fine Arts.
Pierrot and Harlequin are stock characters from the Mardi Gras carnival. The somber mood of the picture and the melancholy expression of the figures are out of tune with the usually gay and spirited atmosphere evoked by this subject. Cézanne painted the picture in dense strokes, clearly designating the outlines. He exploited the juxtaposition of the model's costumes—the loose white clothes of Pierrot and the close-fitting garment of Harlequin. The models for this work were Louis Guillaume (Pierrot) and the artist's son, Paul (Harlequin).

Self-portrait with Beret

1873–1875; *oil on canvas*; 21 2/3 x 15 in. (55 x 38 cm.).
St. Petersburg, Hermitage.
The rather somber range of colors is reminiscent of Cézanne's earliest works, although the brushstrokes here are calmer and more flexible. This likeness is painted with a greater sense of simplicity and austerity, leaving behind the romantic expressiveness of what the artist later called the "couillarde" period. Around the same time, in 1874, Camille Pissarro painted a portrait of his friend with a similar outward appearance.

to find solutions for his pictorial problems. Vollard reports that he sat 115 times and even then the painting was not yet considered finished. When Vollard drew the painter's attention to two spots on the hands where the canvas was not covered, Cézanne responded that he had to find the right color to fill these minute white spaces. "If I put something there at random," the artist responded, "I should have to redo the entire picture, starting from that very spot." This dictum illustrates Cézanne's intensive procedure and his unceasing concern for finding the right balance of form and color.

It is true, however, that during his romantic period, in the 1860s, Cézanne painted portraits much more rapid-

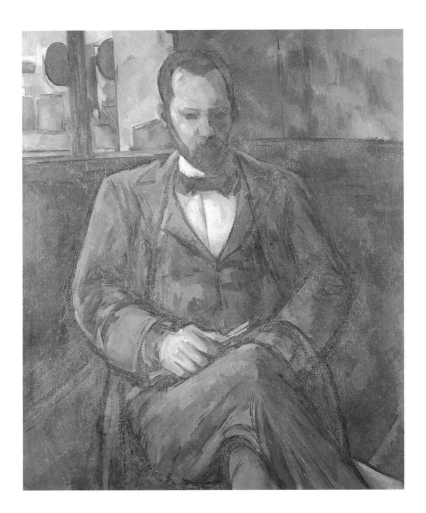

Ambroise Vollard
1899; *oil on canvas*; 39 1/2 x 32 in. (100.3 x 81.3 cm.).
Paris, Musée du Petit-Palais.
The art dealer Ambroise Vollard organized the first major retrospective of Cézanne's work at his gallery in 1895, in which 150 paintings were exhibited. A few years later Cézanne painted his portrait during numerous laborious sessions. The sitter's brown suit is set against a darker brown background; the head, the white shirt, and the pinkish hand over crossed legs form the focus of attention. The paint has been applied thinly and does not reveal the reported 115 sittings the portrait took to complete.

ly—even at times in a single session, as is reported for the series of pictures of his uncle Dominique. But after having learned to carefully compose his works, and with his impetuous attitude in check, Cézanne became more self-conscious about the act of creation and held a much tighter control over what he called his "sensations."

Mature Portraits

Self-portrait with Beret illustrates the transition from the early period toward a more mature style. The somber hues link the painting to previous works, but the brushwork has become calmer and more flexible. Also the simplicity of the image and a reduced emotional expressiveness are proof that he has gained greater self-control, especially when compared with the self-portraits done slightly earlier. The painting was possibly begun during his stay in Auvers, at which time Pissarro's constructive influence had an enormous impact on Cézanne's artistic development.

A more introspective artist is looking out of *Self-portrait*, painted about a decade earlier. Here his features are relaxed and gentle, his sparkling eyes revealing wit and a mocking spirit. The outlines are well defined, thus giving this portrait a kind of official touch. Nevertheless, the contrasts of green and orange give this image a powerful expressiveness. Surprisingly, Cézanne painted only one work in which his likeness includes elements other than his head or upper torso. In his *Self-portrait with Palette* (c. 1890), we see him as a painter standing with his palette in front of the easel. The composition was apparently derived from Rembrandt's self-portrait with palette in the Louvre, which had served as a model for Vincent van Gogh's *Self-portrait as a Painter* about two years before. Ignoring Rembrandt's dark tonalities and his play of light and shadow, Cézanne analyzed the painting's underlying composition. In his own work he constructed a series of parallel lines, diagonals, and contours which form a rich pattern of rhythms and harmonies. For example, the edge of the easel, placed at an angle, is skillfully played off against the rectangular image as a whole, while the left edge of the palette coincides with the outer contour of his right arm. All these pictorial elements together with a homogeneous brushwork and color range make this a highly balanced, albeit somewhat calculated, image in which concern for compositional details outweighs pictorial expressiveness. In fact, this work has been called by one critic "one of the most impersonal self-portraits we know."

Portraits of Madame Cézanne

A similar detachment from the sitter is found in the portraits of his companion and future wife, Hortense Fiquet. A number of her portraits were painted between 1885 and 1890, a period when the couple regularly lived

together. Their relationship had always been a strenuous one from its beginnings in 1869, when Cézanne met Hortense most likely in her role as a model for painters. Afraid of his father's accusations of squandering his hard-earned money and wary to see his monthly allowance cut down, Cézanne made all possible effort to hide her existence from his family. Knowing that Louis-Auguste would indiscriminately open all his mail, Cézanne instructed his friends in Paris not to mention Hortense in their letters to him during his stays in Aix. Nevertheless, first his mother and sisters, then later his father, learned about the relationship and the existence of a child, Paul, born in 1872.

Hortense Fiquet seems to have been a lively and quick-spirited person, but with little interest in the arts or the intellectual concerns with which Cézanne tormented his own mind. She was not welcome at Jas de Bouffan, even after the couple got married in April of 1886. Most of the time, Cézanne lived apart from Hortense and young Paul. He always spoke with warmth and admiration about his son, but he rarely mentioned his wife to his friends.

This alienation and distance is palpable in almost all the portraits of Hortense. In *Madame Cézanne in Blue Vest* an expressionless, immobile face looks out at the viewer. Yet her regular features are not without a hint of sympathy, and her eyes reveal some of her warm and nurturing character. Perhaps only a person as patient and gentle as Hortense was able to deal with Cézanne's constantly brooding and problematic nature. Tension and motion are not made visible on a psychological or physical level but are expressed solely through formal and coloristic means. The sitter's hieratic frontal pose, underlined by the vertical button line of her blouse, has been animated by a slight tilt of her head toward the left. The background is divided into two contrasting sections. A half-opened door of light blue with the horizontal and vertical lines of its panels is distinctly separated from the brownish wall-space on the left, where the curvilinear shapes of a buffet and oval ornaments of the wallpaper perform an antagonistic function in this composition.

Between 1888 and 1890 Cézanne occupied a large apartment on the Isle Saint-Louis in Paris, where he painted Madame Cézanne in a Yellow Armchair. The location can be identified by the brown stripe which ran around the living room above the molding and which appears in other works from this time as well. Very little, if anything, of Hortense's personality can be made out in her figure. Even more than in the previously discussed work, her features are fully integrated into the overall scheme of the composition. The oval form of her head is echoed by the round shapes of her arms and folded hands. The pink color on her cheeks seems to be more a reflection of her crimson dress than a natural state. The flat spatial elements around her, the back of the yellow chair

and the turquoise wall, serve as a foil to the volume of her dominating presence. The combination of these elements provide the painting with an aura of steadfastness and stolidity. The slight angle of her pose has been counterbalanced by fixing the dark stripe on the wall behind the chair to the left at a higher level than on the right.

Later Portraits

The only portrait which reveals something of Cézanne's sitter's personality and interests is that of *Victor Chocquet in a Chair*. Renoir had introduced the collector to the works of Cézanne at Père Tanguy's paint shop in Paris, and soon he became one of the artist's earliest and

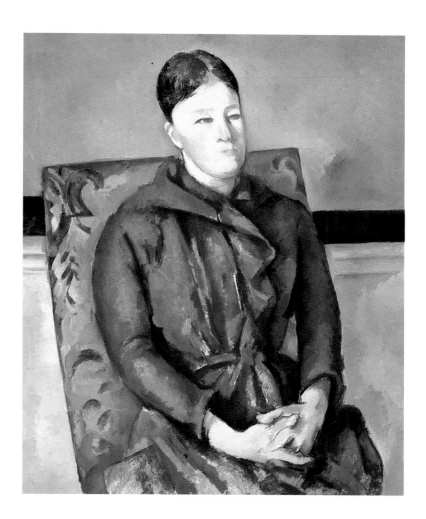

Madame Cézanne in a Yellow Armchair
1893–1895; *oil on canvas;* 31 3/4 x 25 1/2 in. (80.9 x 64.9 cm.). Chicago, The Art Institute.
The artist painted his wife throughout his career. This is one of three versions of a similar pose and setting. The simplicity of the forms—rectangular shapes for the space and chair, round forms for the human body—create an atmosphere of utmost density and solidity. The primary colors—blue, yellow, and red—are united around the sitter's mouth, thus pulling the composition tightly together. The dado rail behind the chair is placed a little higher on the left side as if to balance Mme. Cézanne's slightly tilted pose.

most devoted patrons. Chocquet shared with Cézanne an immense admiration for Delacroix, of whom he owned several watercolors. When he purchased his first painting by Cézanne, a scene of bathers, Chocquet exclaimed: "How splendid it will look between a Delacroix and a Courbet." The two men often dined together at the collector's apartment, which served as a backdrop for this portrait. Surrounded by his precious furniture, rugs, and paintings, Victor Chocquet is sitting casually on an armchair, with his legs crossed and his elongated hands leisurely folded. The houseshoes indicate that he is comfortable in his own environment. His silver-gray hair and beard frames the slightly melancholic face of a nervous aesthete. The oval red ornaments on the wall, which pick up the color from the rug and the armchair, enliven the space with their flamelike dots.

Two pictures of men sitting on a chair with their legs crossed illustrate Cézanne's late figure painting. In its monumental simplicity, *Sitting Peasant* (c. 1902–1904) is a powerful expression of humility and modesty, character traits which Cézanne admired in the local people of his

hometown. The color pigments have been applied with thin layers, which evoke the quality of watercolors. The range of hues is mostly limited to greens and blues. *The Gardener Vallier*, dating from the artist's final year, shows Cézanne's gardener at his studio at Les Lauves. The unfinished work is executed with quick, cursory brushstrokes, but the palette is lighter and more varied.

Other figure paintings are not portraits in the strict sense, since the sitters serve merely as models, but in *Mardi Gras (Pierrot and Harlequin)* (1888) we find the artist's son, Paul, in the costume of the Harlequin. Louis Guillaume modeled for Pierrot. The melancholy on their faces and the uneasy, almost tragic, mood of this painting contrast with the joyful atmosphere one usually expects to encounter with the carnival theme. Playing the two figures off of one another, the white voluminous costume of Pierrot contrasts with the tight-fitting, dark clothes of the Harlequin. In their attitudes too the figures convey opposites—a self-conscious masculine presence in the Harlequin and a softer, more feminine appearance in Pierrot.

Allegories

The theme of the opposing sexes considered earlier was treated anew in a couple of paintings which bear allegorical or fantastical features. The difficulties Cézanne experienced in his relationship with Hortense were in fact born of his problematic relationship with women in general. In a subject as well as title picked up from Édouard Manet (*Olympia*, which had caused an uproar at its first public showing at the Salon in 1863), Cézanne's *A Modern Olympia* was chosen by the artist for the first Impressionist exhibition in 1874 as the showcase for his vision of the well-known temptation scene. Artistically, however, the two pictures have very little in common. Whereas Manet's work depicts a proud, self-conscious prostitute whose tense eyes look straight out of the painting, Cézanne portrays a drowsy and melancholy woman lounging on the white sheets of her bed. A visitor, the artist himself, is seen sitting in the foreground, his top hat placed behind him on the couch, staring from a distance at the woman in front of him. A black servant has arrived to cover her nakedness with a linen (or has just unveiled her?). A bouquet of flowers,

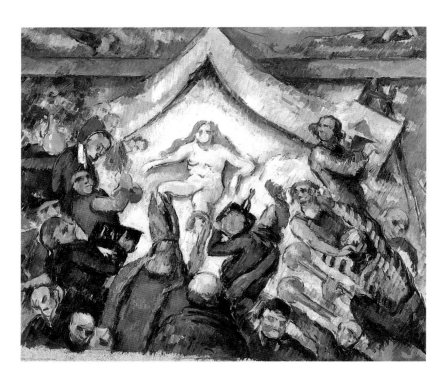

The Eternal Feminine

c. 1877; *oil on canvas*; 17 x 20 15/16 in. (43.2 x 53.3 cm.).
Malibu, California, The J. Paul Getty Museum.
Continuing the subject of confrontation between the sexes, Cézanne presented "The Eternal Woman" in an ironic setting. A throng of male admirers (including the artist himself, recognizable by his bald head at the center) from all classes of society—including musicians, and a bishop— is parading around the idol of a naked woman stretched out on a canopied bed. She receives ovations from all those willing to act as her servants, while at the same time remaining distanced and unapproachable.

Bathsheba

1875–1877; *oil on canvas*; 11 1/2 x 10 in. (29 x 25 cm.).
Paris, Musée d'Orsay.
The subject of Bathsheba at her bath, of which there are two variants, has apparently been chosen for its sexual overtones and was not intended to be seen as an illustration of a popular religious scene from the Old Testament. Sitting precariously on a rock, Bathsheba, with a female attendant at her side, leans backward offering her nude body to the viewer.

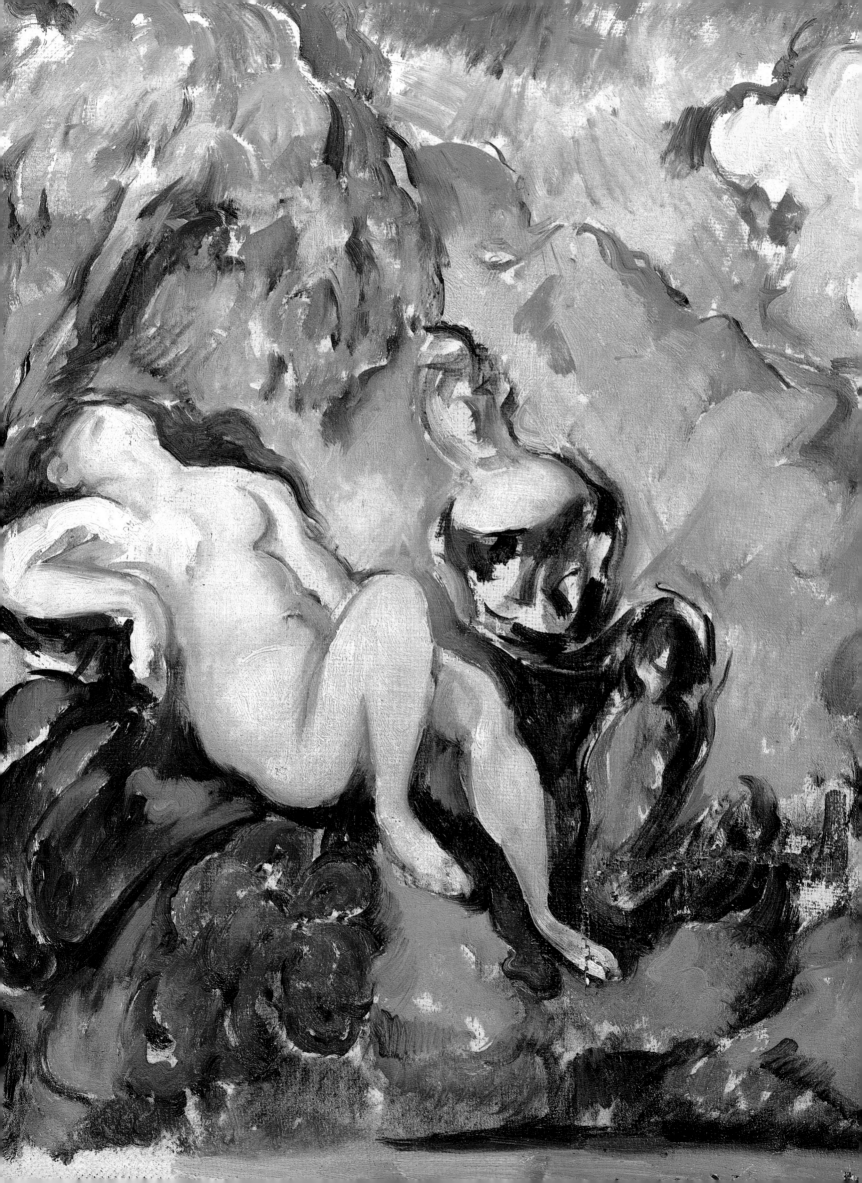

wine, and a basket of fruit complete the debauch. As in a fantastic, delirious dream the artist-visitor acts as a sort of libertine pasha contemplating the female flesh.

The same subject was repeated somewhat later, in *The Eternal Feminine*, with a similar orgy of bright, vigorously-applied strokes of color. Here a group of various members of society, including an artist, a bishop, and a businessman, is gathered around the idol of a naked woman, who presents herself to her male admirers under a huge canopy. She receives the ovations of those who submit to her caprice. Later in his life, Cézanne objectified this allegory of the female temptress, converting the image of the femme fatale into that of a female bather, used as a purely formal device for creating a composition. The sexual attraction/threat had now found its expression in a subtle form of sublimation.

Sexual overtones also characterize *Afternoon in Naples: The Rum Punch* and *Leda and the Swan*. The latter is based on the traditional classical myth, although Cézanne altered the encounter between Zeus, disguised as a swan, and the beautiful Leda as he portrays, with an ironic sense of humor, the swan holding the hand of his beloved woman in his beak. The modeling of Leda's body is defined almost wholly by color. The sky-blue background, the strikingly blue pillow with yellow tassel, and the bluish white of the swan/Zeus, the cloth, and the bed, serve as the coloristic backdrop for the pinkish flesh of the female hero. *Afternoon in Naples: The Rum Punch* is a later version of previous works in which sexual pleasures and alcohol are the sole and explicit subject. Prostrate on a bed, a man and a woman—understood to be a prostitute—are seen from the back, unmistakably engaged in an amorous embrace, while a black servant in yellow turban with a red cloak around his waist appears with refreshments. The exploitation of the effects of a bright palette and the clear spatial relationship of the composition allows one to date this work in the years around 1875–1877. The rather poetic title was probably suggested by Cézanne's friend, painter Antoine Guillemet.

Still-life

A large part of Cézanne's artistic productivity was dedicated to painting still-lifes. Early examples of this genre, such as *Still-life: Pots, Bottle, Cup, and Fruit* or *Still-life: Green Pot and Pewter Jug*, followed traditional patterns as established in the seventeenth and eighteenth centuries. The colors in these early works were rather somber, according to the artist's own preference, but inevitably this situation changed after Cézanne came under Pissarro's influence. And in *Green Apples* (c. 1873) light had begun to play a more decisive role.

Still-lifes were an ideal subject for a slow-working artist like Cézanne. The inanimate objects of course would not

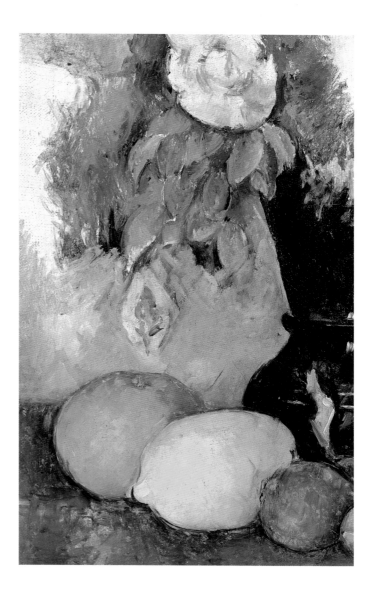

Flowers and Fruit
1879–1882; *oil on canvas*; 13 3/4 x 8 1/4 in. (35 x 21 cm.).
Paris, Musée de l'Orangerie.
This still-life is characterized by a simplicity of design and delicacy of coloring. The fruit is arranged in order of size, but also by occurrence of the colors in the spectrum, namely orange, yellow, green, and blue. The surface has almost lost its texture in favor of clearly defined color fields. Cézanne might have worked on this painting at different periods, but eventually left it unfinished, as the raw canvas on the upper left and right indicates.

Still-life with Soup Tureen
c. 1877; detail. Paris, Musée d'Orsay.
Cézanne had a great admiration for ordinary objects of everyday life such as olive jars, fruit baskets, clay pipes, and others. In his studio at Les Lauves a number of these objects are still in their place. This soup tureen, however, might actually have belonged to Camille Pissarro, since the painting was apparently executed at his home in Pontoise.

move during the painting sessions and they were available any time of day or night. Most of his still-lifes are of fruit rather than flowers for the simple reason that flowers wilt rather quickly. This also explains why Cézanne chose most frequently apples, oranges, and lemons rather than peaches or strawberries, which would have been equally accessible. Although they were painted in the controlled environment of the studio, the subject was still that of nature. Cézanne's still-lifes breathe something of the vastness of the world outside, while at the same time working on these canvases indoors helped the artist to create the continuum of space in his landscapes.

Still-life with Soup Tureen was painted in Pontoise around 1877 at Pissarro's house. The colorful terra-cotta tureen probably belonged to the older artist. And the paintings on the wall were Pissarro's own works. The arrangement of the fruit basket, the tureen, the wine bottle, and the two apples on the square table covered by a red tablecloth with a floral pattern, is rather conven-

tional and does not challenge traditional values of perspective with the exception of a slight awkwardness in the lid of the tureen. Depicted is a peaceful world of sensuous color and rigorous discipline. The rectilinear lines of the frames on the wall establish a firm rhythm of perpendiculars which control the undulating objects on the table. The color range displays a richness as yet unprecedented in Cézanne's oeuvre, as if he wanted to prove that he was able to paint with the same brilliance and diversity as his Impressionist colleagues. Yet there is an element of suppressed energy in this painting which betrays its creator. The fruit basket is overflowing and in fact two apples are lying on the table in front of it while the dark wine bottle with its swelling form appears to press almost against the soup tureen.

A more condensed and intensified style becomes apparent in *Flowers and Fruit*, painted a few years later. Less descriptive than in the previously discussed work, Cézanne seems to have focused his attention more on the shapes of the objects displayed and on the interference of their presence to one another. The fruit has lost its sensual appearance and is arranged in order of size; it is also arranged in the order of occurrence of the colors in the spectrum: orange, yellow, green, and blue-green. The same curvilinear shapes occur in the pink flower at the top and in the dark vase on the right. One can feel the artist's sense of order and spatial relationships, which was so crucial in his later still-lifes, and which illustrate complex arrangements.

Why Still-lifes?

For Cézanne the objects he depicted had a deeper meaning. He appreciated particularly fruits and flowers as the products of nature, and also common domestic objects like pitchers, jars, and bottles, which he felt held an admirable sense of craftsmanship. In a number of still-lifes these same objects appear again and again, each time in a different context that explores their multifaceted aspects. Contrary to what is sometimes assumed, certain objects actually traveled with the artist between Paris and Aix, therefore making it difficult to date his works in regard to certain subjects.

Cézanne's late still-lifes—from about 1890 on—are characteristically rich in the sensuousness of their warm

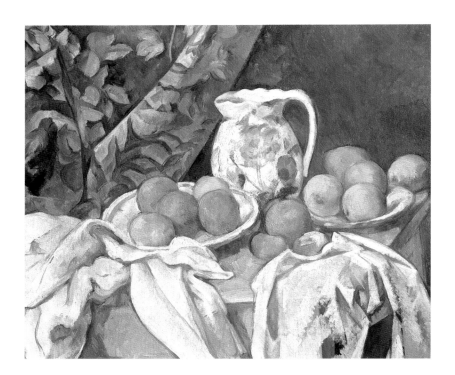

Still-life with Curtain and Flowered Pitcher
c. 1899; *oil on canvas*; 21 1/2 x 29 1/8 in. (54.7 x 74 cm.).
St. Petersburg, Hermitage.
The same drapery and flowered pitcher here appear also in
Apples and Oranges. *At first sight this still-life seems to be a straightforward rendering of a classical subject. Upon closer observation, though, anomalies become apparent; for example in the central dish, which is precariously tilted toward the viewer. Cézanne followed singular principles through which he tried to heighten the tangible reality of the objects and adjust the tonal values in relationship to one another.*

Still-life with Fruit Basket
c. 1890; detail. Paris, Musée d'Orsay.
The round forms of the ginger pot and sugar bowl echo the shapes of the nearby fruit, thereby bringing man-made objects and nature into a harmonious kinship. A napkin or tablecloth, which has been pulled aside, breaks the monotony and serves as a neutral backdrop for a colorful display.

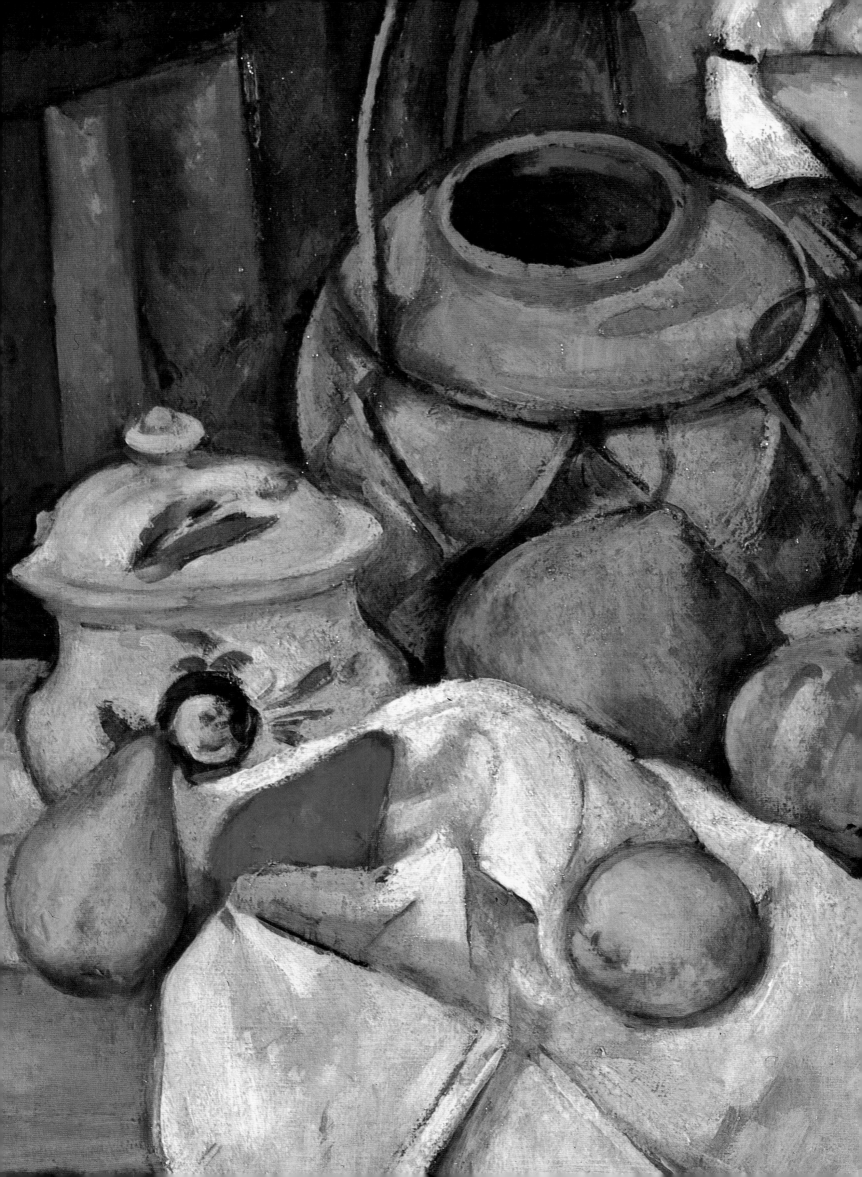

hues and magnificently orchestrated compositions. *Apples and Oranges* from about 1896 is a classic example for this type. Over an elaborately folded white tablecloth mountains of fruit and dishes rise in an apparently overflowing arrangement. Two different draperies, one with brown and purplish squares and a dark green and red design, the other with a blue and ocher pattern, enrich the already crowded space. The whole ensemble is precariously situated on a table whose precise shape and location remain elusive. The white pitcher with its floral decoration eases the transition from the fruit to the colored textiles. Although unusually crowded, every object in this composition has its precise pictorial function. To take one apple or orange away would throw off the balance of the painting.

Less claustrophobic is the *Still-life with Fruit Basket* (c. 1890), where much of the studio space has been included. The objects barely fit onto a narrow table where a large basket with fruit and napkins is the most conspicuous item. The purple-blue ginger pot at its left appears in a number of other paintings as well. The large white tablecloth binds the various smaller objects into a fluid whole. Foreground and background are integrated through similar color modulations. The rather odd leg of a table or chair on the right seems to push the basket back onto its place on the table. On the left appears a folding screen that Cézanne had painted in the late 1850s for the Jas de Bouffan. However, such a quotation of his own work is not unique in his oeuvre. The rare signature, on the other hand, was probably added when this work was acquired by his friend Paul Alexis.

The same flowered pitcher seen in *Apples and Oranges* can be found in *Still-life with Curtain and Flowered Pitcher* (c. 1899). The painting also contains the same brownish curtain with leaves. At first sight this seems to be a rather straightforward rendering of classical still-life objects, but irregularities emerge upon closer observation. The central dish is tilted in a way that it seems to slide off the table toward the viewer. Additionally the tabletop is slanted toward the left and the perspective of its right side is also awry. Yet such seemingly incongruous features appear to be less arbitrary when we consider the composition in its entirety. In their formal and tonal relationships these elements balance each other in a harmonious way while at the same time heightening our experience of forms in space.

A testimony by an acquaintance in 1898 describes Cézanne's method of preparing a still-life: "No sooner was the cloth draped on the table with innate taste than Cézanne set out the peaches in such a way as to make the complementary colors vibrate, grays next to reds, yellows to blues, leaning, tilting, balancing the fruit at the angles he wanted, sometimes pushing a one-sou or two-sous piece under them. You could see from the care he took how much it delighted his eye."

Apples and Oranges

1896–1900; detail. Paris, Musée d'Orsay.

Cézanne painted his canvases meticulously with thin layers of translucent paint. This procedure allowed for quick drying and made almost instantaneous corrections or alterations possible. The surface of a canvas thus acquired a rich texture and a countless variety of color hues.

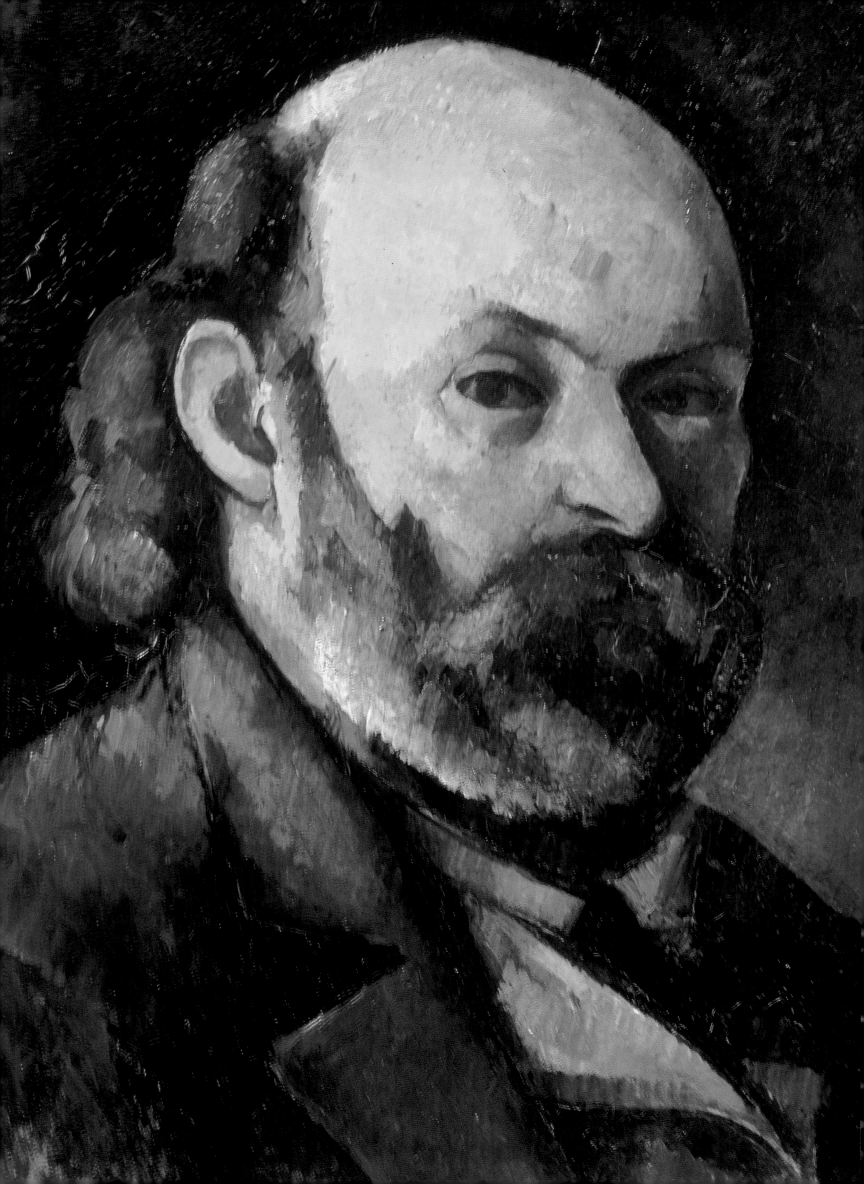

Self-portrait with Palette

c. 1890; *oil on canvas;* 28 3/4 x 36 1/4 in. (92 x 73 cm.).

Zurich, E.G. Buehrle Foundation.

This is the only self-portrait in which Cézanne depicted himself as an artist. The back of the canvas and the palette, tilted up so that it appears parallel to the picture frame, block off any immediate access to the sitter, whose eyes are focused on the easel in front of him. The dark beard framing his features is echoed by the brown overcoat, leaving his white shirt visible. For Cézanne the artist had to remain in the background, while "the pleasure must stay in the work."

Self-portrait

c. 1880; *oil on canvas;*

17 3/4 x 14 1/2 in. (45 x 37 cm.).

Moscow, Pushkin Museum of Fine Arts.

During the early 1880s, Cézanne painted a number of similar self-portraits. In this example, the modeling of the face is based upon expressive contrasts of green and orange. The paint is applied with regular, systematic brushstrokes and the outlines are clear and well defined, which make the painting appear to be somewhat stiff and official. This is one of the few self-portraits in which the artist bears a gentle expression.

Madame Cézanne in Blue

1885–1887; *oil on canvas*; 29 x 24 in. (73.6 x 61 cm.). Houston, The Museum of Fine Arts.

As in most portraits of his wife, as well as in those of his relatives and friends, Cézanne often expressed his own solitude and alienation. Here, the sitter confronts the viewer with a startling immediacy and directness, however, without an inviting gesture that would allow one to "communicate" with Mme. Cézanne. Placed between the bright, cool blue of the door in the background and the dark, warm colors of the wallpaper and buffet to the left, her slightly tilted head appears motionless and conveys a hint of sadness.

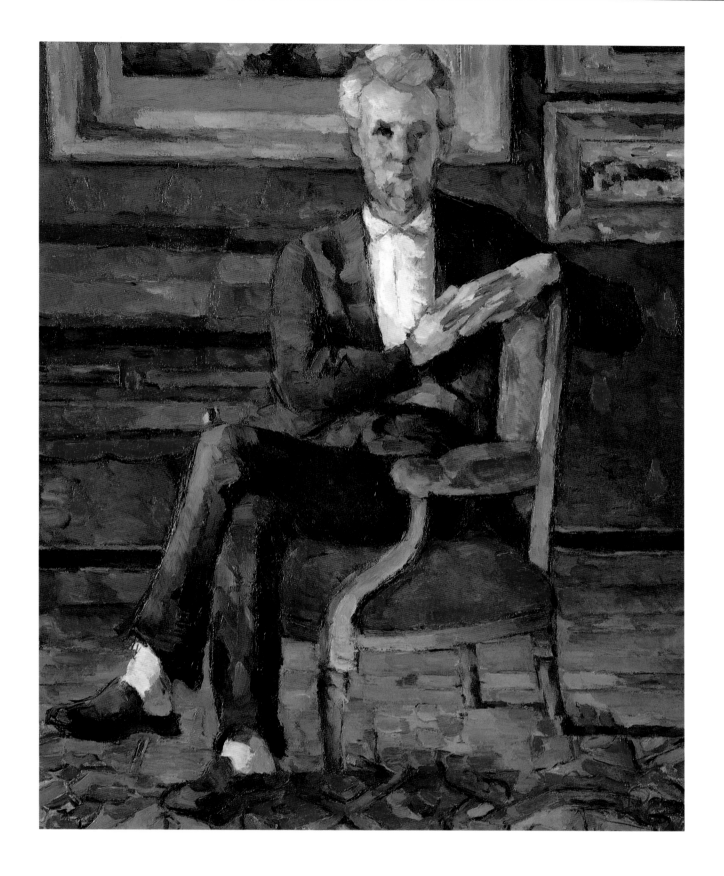

Victor Chocquet Seated

c. 1877; *oil on canvas;* 18 1/8 x 15 in. (46 x 38 cm.). Columbus, Ohio, Columbus Museum of Art.

Victor Chocquet, a customs official with a passion for contemporary art, was first introduced to the artist by Auguste Renoir in 1875. Chocquet purchased his first Cézanne painting via dealer Père Tanguy, exclaiming, "How nice this will look between a Delacroix and a Courbet." Chocquet became an important collector of Cézanne's work, owning over thirty of his canvases at the time of his death in 1891. This is one of the painter's rare portraits in which the environment reveals something of the sitter's interests and activities.

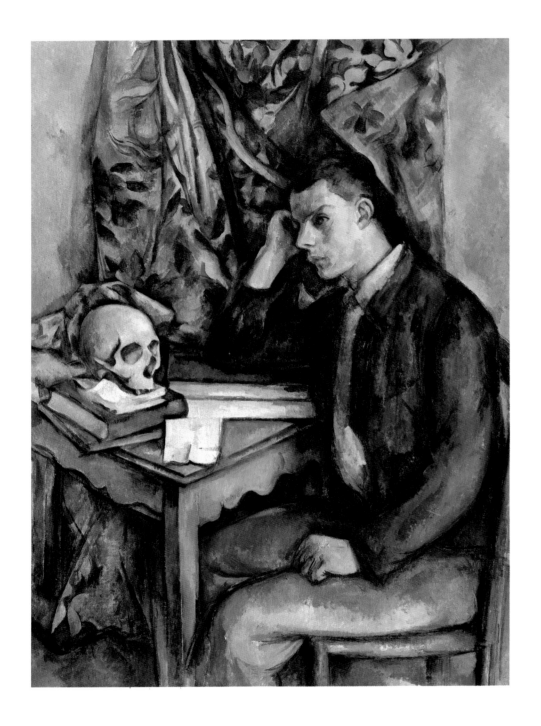

Boy with Skull

1896–1898; *oil on canvas;* 51 1/4 x 38 1/4 in. (130.2 x 97.3 cm.).

Merion, Pennsylvania, The Barnes Foundation.

*Sitting at a table, his elbow resting on a pile of books, a young man stares
into space past a skull that lies in front of him. Skulls were traditional
symbols in "vanitas" still-lifes and Cézanne, who considered them "a beautiful
thing to paint," frequently included them in his works. There is a heroic
nature to this youth, and the monumental character of the painting was
intended to place it within a long-standing tradition in the history of art.*

Boy in a Red Vest

1888–1890; *oil on canvas;*
31 1/2 x 25 3/8 in. (80 x 64.5 cm.).
Zurich, E.G. Buehrle Foundation.
*Since it was first exhibited at the
one-man exhibition at the Galerie
Vollard in 1895, this work has
been considered one of Cézanne's
most beautiful images. The model,
an Italian youth by the name of
Michelangelo di Rosa, is sitting at
a table with his head resting on
his left hand. This traditional
pose recurs several times in the
artist's oeuvre and expresses
thoughtfulness or at times even
deep melancholy. The room appears
to be one from Cézanne's apart-
ment at 15 quai d'Anjou in Paris.*

Onions and Bottle
c. 1895; *oil on canvas;*
26 x 32 1/4 in.
(66 x 82 cm.).
Paris, Musée d'Orsay.
Set against an unusually
large expanse of wall,
many objects are set on
a crowded table in a
diagonal movement that
leads from the folds of
the white tablecloth at
the lower right toward
the cork of the dark-
green bottle in the rear
left. The green shoots
of the onions are utilized
as a kind of decorative
pattern throughout the
still-life. As in many
of Cézanne's works the
perspective appears
somewhat awkward,
and is apparent here
in the receding tabletop
on its right edge. The
thinly applied paint is
rich in color gradations.

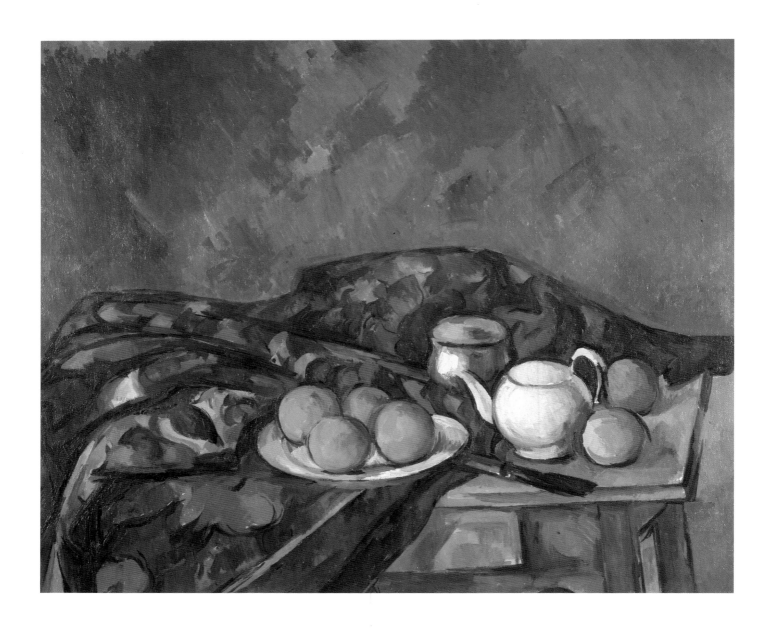

Still-life with Teapot

1902–1906; *oil on canvas;* 23 x 28 1/2 in. (58.4 x 72.4 cm.).
Cardiff, National Museum of Wales.
*It is difficult to discern which of the four round shapes
of the fruit placed on the elliptic white plate are apples,
oranges, or apricots. But their identity hardly matters.
Their existence is reaffirmed by the white teapot and
sugar bowl, whose round forms respond to those of the fruit.
The curvilinear border of the table has the same function.
The mountains of colorful tablecloth seem to thrust the
objects further toward the picture plane, while diagonally
the knife establishes a sense of balance in the arrangement.*

The Blue Vase

1885–1887; *oil on canvas;* 25 1/2 x 19 2/3 in. (65 x 50 cm.).
Paris, Musée d'Orsay.
*More concerned with coloristic effects than with "correctly"
drawn perspectives, Cézanne placed the objects of his still-
lifes with great care according to their color values in the
picture. Set against a light-blue wall, the flowers, fruit,
and vase exhibit intense hues of green, red, white, and dark
blue. The outlines of the vase have been repeatedly drawn
in fine blue, white, and red strokes of paint, thus creating a
three-dimensional effect, an aspect which excited the Cubists.*

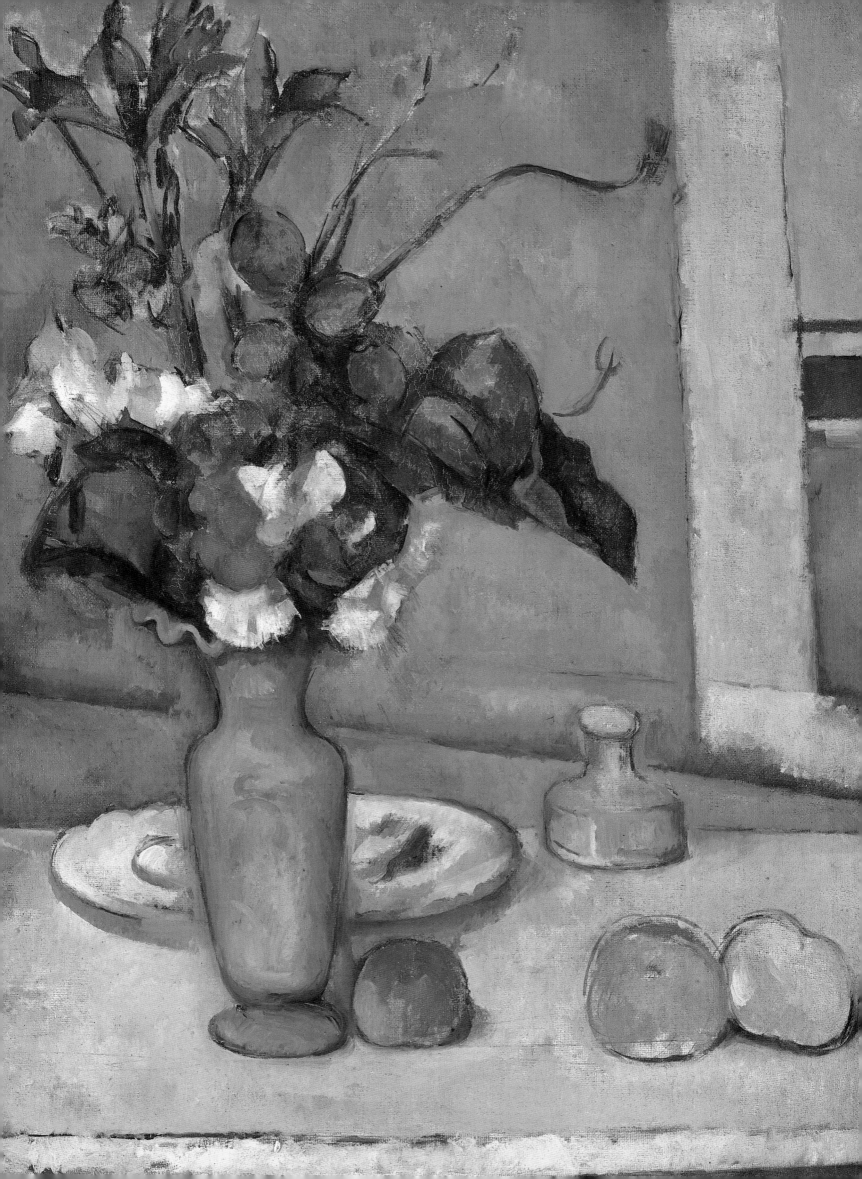

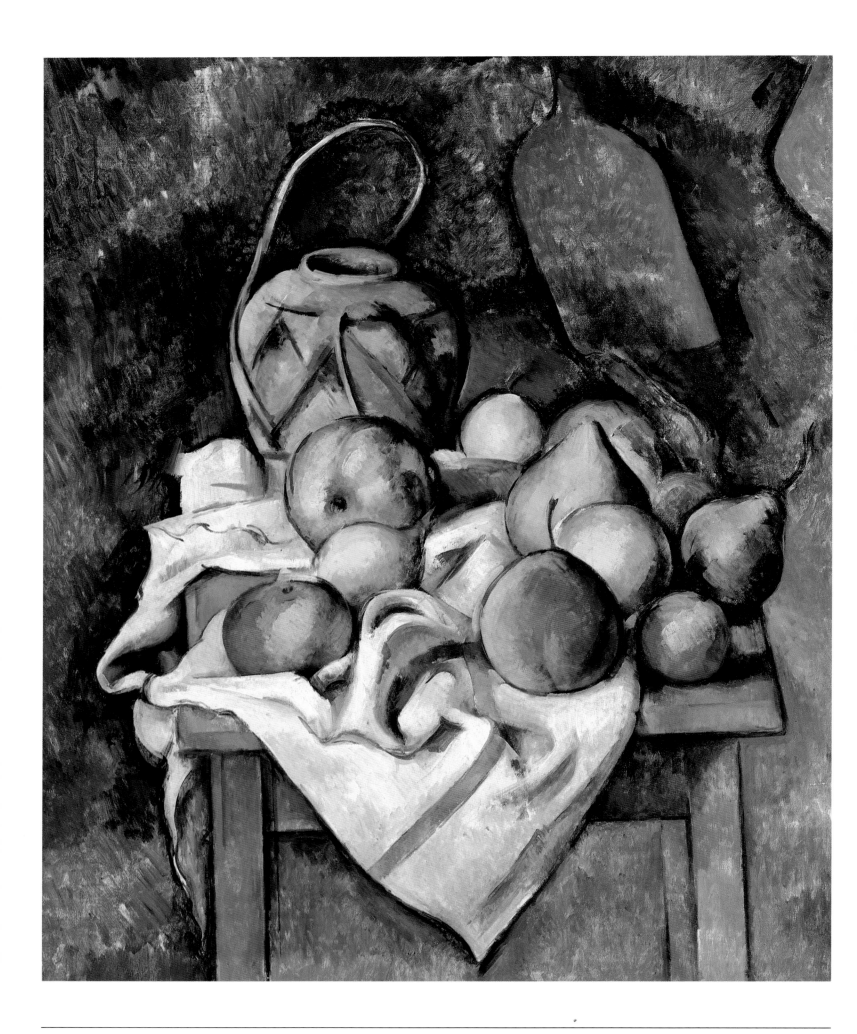

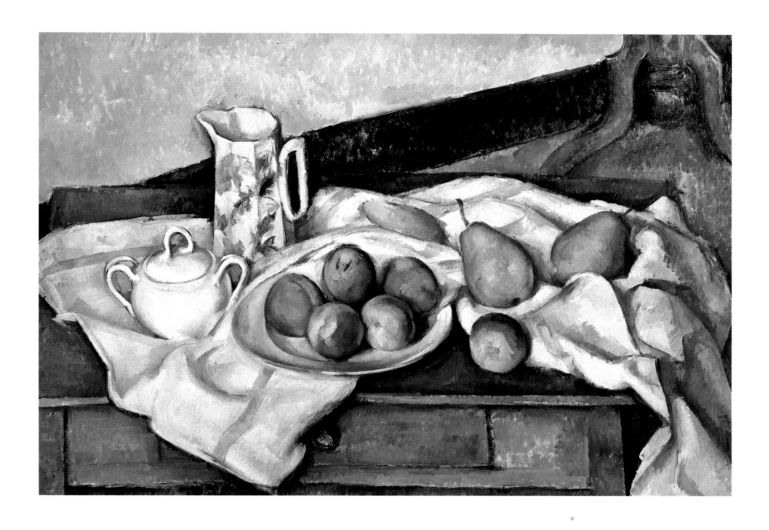

Sugar Bowl, Kettle and Plate with Fruit
1888–1890; *oil on canvas*; 24 x 35 1/2 in. (61 x 90 cm.).
St. Petersburg, Hermitage.
The white of the tablecloth and china is painted
with particularly fine tonal gradations, and is
juxtaposed to the bright colors of the fruit. There is
no classical light-and-shade modeling in this painting,
which is done with heavily applied strokes in its main
parts while the background is noticeably thinner, with
the canvas visible under semi-translucent layers of paint.

Ginger Jar and Fruit (Le vase paillé)
c. 1895; *oil on canvas*; 23 3/4 x 23 5/8 in. (73 x 60 cm.).
Merion, Pennsylvania, The Barnes Foundation.
On a boldly tilted tabletop, apples and pears are
displayed with strong colors under a bright light.
The same ginger jar in the rear appears in at least
ten other paintings but each time Cézanne invented
the composition anew, offering different solutions to the
pictorial problems of space, light, and color. The back-
ground takes up the blue and purple of the ginger jar,
while red and green touches recall the fruit on the table.

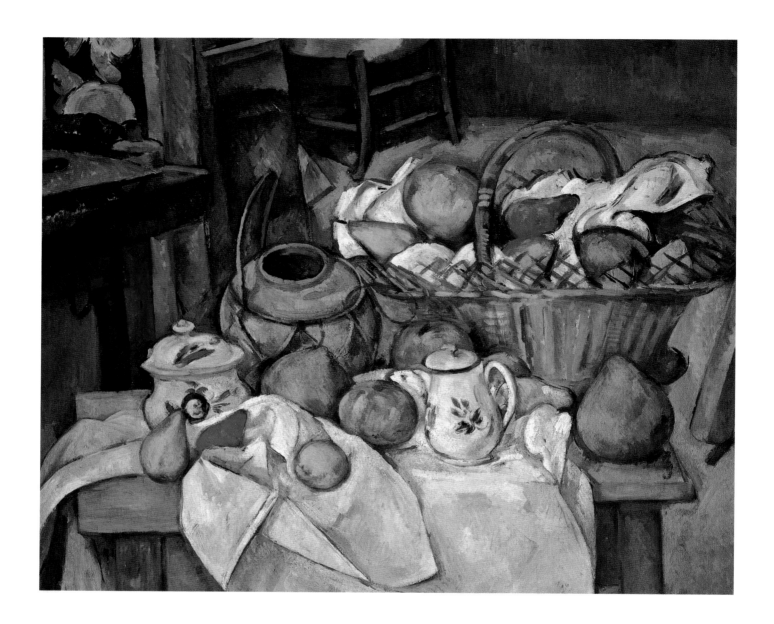

Still-life with Fruit Basket

c. 1890; *oil on canvas*; 25 5/8 x 31 7/8 in. (65 x 81 cm.).
Paris, Musée d'Orsay.

An elaborate still-life of fruit and objects is displayed on a small table. It was probably painted in the attic studio of the Cézanne family mansion, Jas de Bouffan. In the background Cézanne quotes one of his own earlier works, a painted screen, which dates back to the late 1850s when he decorated the house together with Zola. Here it serves as a compositional device, closing the design at the left side behind the high table.

Vase of Flowers and Apples

c. 1890; *oil on canvas*; 22 x 18 1/4 in. (56 x 46.5 cm.).
Zurich, Private Collection.

This same green-glazed olive jar appears in a number of other paintings and works on paper. The rectilinear lines of the tabletop and divisions in the background find a peculiar balance in the hidden analogies of the curvilinear shapes of the fruit, the vase, and the flowers. The two pieces of fruit, probably oranges but usually referred to as apples, are important for the balance of the composition. The brushwork ranges from passages that are like transparent washes of watercolor to areas of more saturated painterly hues; yet others are directional and rhythmic.

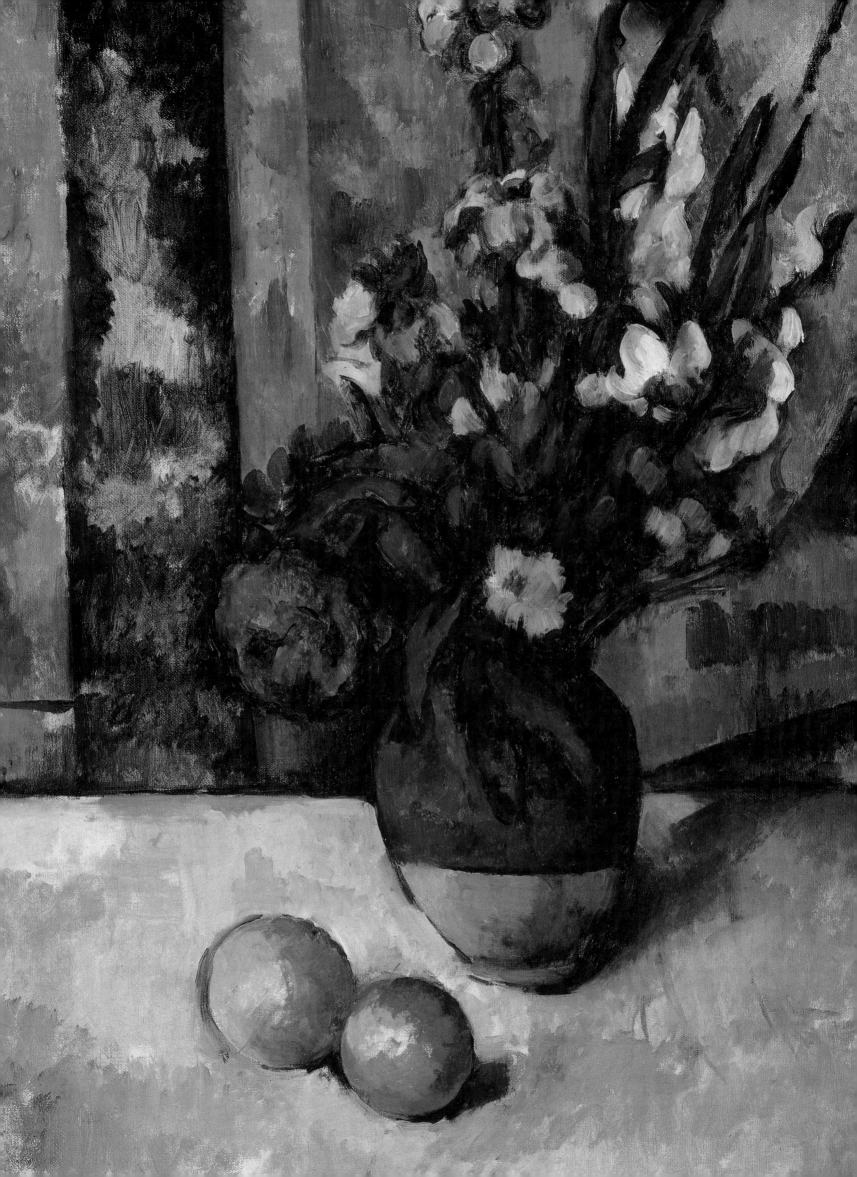

CHAPTER 4

THE LATE WORK

From about 1890 until his death in 1906, Cézanne focused on three major subjects: the Cardplayers, the Bathers, and the Mont Sainte-Victoire. With the exception of the cardplayers he had treated these themes before, but now he explored their range with an unprecedented obsession. In his late works he achieved a new intensity of color and form; their content became more profound and even more somber and mysterious than anything else he had done earlier. The advanced degree and analytical force of abstraction as well as the dominance of powerful color schemes in Cezanne's late works made a lasting impact on younger painters such as Henri Matisse, Georges Braque, and Pablo Picasso, who themselves were to influence painting in the twentieth century.

Cardplayers and Pipe Smokers

Cézanne's new note of somberness and mystery, especially in the figure paintings, reflects a dark, flickering spirituality reminiscent of the art of Flemish and Dutch masters, Rembrandt in particular. The subjects are often melancholic and meditative. The new color harmony becomes obvious when looking at the series of cardplayers and the studies of individual figures which led to them. Among the latter is a group of male figures smoking pipes.

According to the daughter of the peasant depicted in one of the paintings the series was begun in 1890, and it was still in progress the following year. Therefore the whole series is generally dated 1890–1892. In three canvases—the two *Pipe Smokers* and *The Smoker*—single peasants are seated at a table, leaning to the left and resting their head on their arms. A similar contemplative, sad

pose appeared in earlier works, such as *Boy in a Red Vest* (1888–1890), and in *Boy with Skull (1896–1898)*, but also as early as *Sorrow, or Mary Magdalen* (c. 1867). From the beginning, this posture carried for Cézanne a sense of romantic pathos and private guilt, which is an essential aspect of his artistic personality. It should also be mentioned that later in his life Cézanne became increasingly concerned with death, a feeling which was accompanied by a renewed interest in religion. Yet if his conversion and subsequent practice of Catholicism were deeply personal, they also belonged to a much larger revival of mysticism

The Smoker
1890–1892; *oil on canvas*; 36 1/4 x 28 3/4 in. (92 x 73 cm.).
Moscow, Pushkin Museum of Fine Arts.
In the background appears a fragment of a portrait of Mme. Cézanne, today in the Institute of Arts, Detroit. The motif of quoting a picture within a picture had a long tradition in European art and was employed several times by Cézanne. Like several other versions of pipe smokers, this work is related to the series of cardplayers, painted around the same time.

The Card Players
1892–1893; *oil on canvas*; 23 2/3 x 28 3/4 in. (60 x 73 cm.).
London, Courtauld Institute Galleries.
The subdued tonality is similar to that of Cardplayers, *in the Musée d'Orsay in Paris. Here the two men are dressed in contrasting jackets, one a cold blue, the other a warm yellow-ocher. Other warm accents revolve around the tabletop, reaching out to the edge of the canvas in a bright red spot. There are certain discrepancies with "natural" vision. The legs of the left player, for instance, reach out too far under the table, yet they have a distinct compositional function in the overall picture scheme.*

and spirituality which pervaded much of French society during the late nineteenth century.

In one of the *Pipe Smoker* paintings, Cézanne partially quoted one of his own, earlier works—*Still-life: Pots, Bottle, Cup, and Fruit* (c. 1871)—which appears at the left side, cut off by the frame, while the right part is covered by the figure. The same procedure occurs in *The Smoker*, where the fragment of a portrait of Hortense Cézanne can be recognized. These quotations of pictures within pictures have a long tradition in western art, and were popular among contemporary painters such as Manet, Pissarro, Bazille, among others. For Cézanne they affirmed the continuity with his previous work, despite the considerable changes his art had undergone in the meantime.

The same subdued tonalities, but among a more positive outlook, can be seen in *Man with a Pipe*. The model, a gardener at Jas de Bouffan, is placed parallel to the picture plane, facing the viewer with an uninhibited look.

He represents an idealized type of a peasant, in whom Cézanne recognized the traditional, timeless values of ordinary country people. His figure appears again in the larger compositions of cardplayers, which occupied the artist during the early 1890s.

Although there is no explicit date available for any of these paintings, it is most likely that the composition scheme developed from the multifigured *Cardplayers* to the other two paintings, which show only two players. Local peasants served as models in all of these works, but it is unlikely that they all sat at the same time, given Cézanne's extremely slow working methods. He might rather have painted each figure separately, thus allowing for a careful development of the entire composition and its color harmonies. In the large painting of the cardplayers three men are sitting around a table playing cards, watched by a young girl looking over a man's shoulder (perhaps her father?) and a pipe-smoking man standing further behind the table. On the wall next to him hangs a framed painting, cut off at its upper edge by the canvas. A jar, several clay pipes, and an elaborate drapery on the right serve to fill the void and to enhance the sense of volume. The space is clearly defined, the sitters firmly positioned in their environment.

The versions with two cardplayers, on the other hand, are lacking this spatial quality, but have gained in intensity and mysterious intimacy. The focus of the composition and the color scheme is on the two men sitting on either side of the table. The rather dark background is not quite defined; its barely noticeable vertical and horizontal lines, however, serve to balance the weight of the colors and to retain the unity between foreground and background. Even more so than in the preceding, larger version of the subject, time seems to have come to a standstill. At the end of his life, Cézanne told Jules Borély: "Today everything has changed in reality, but not for me, I live in the town of my childhood, and it is with the eyes of the people of my own age that I see again the past. I love above all else the appearance of people who have grown old without breaking with old customs." Thus these men appear as unchanged by time as the landscapes of his home's countryside, in particular the Mont Sainte-Victoire.

Le Château Noir
1900–1904; detail.
Washington, D.C., National Gallery of Art.
Cézanne painted Château Noir from a distance, as it emerges above the treetops. Its forms are defined by several layers of thin paint, which at times form an uneven crust. The château exercised a special attraction for the artist, who attempted to purchase it from its owner—but to no avail.

Cardplayers
1892–1895; detail. Paris, Musée d'Orsay.
Time seems to stand still for this cardplayer, with whom Cézanne created the idealized image of a solitary man absorbed in his own world. The artist admired the local peasants of his hometown, who sat as models for his paintings of cardplayers. The motionless face is painted with hues of glowing orange, and the sunken eye has only been brushed in with a simple stroke of brown.

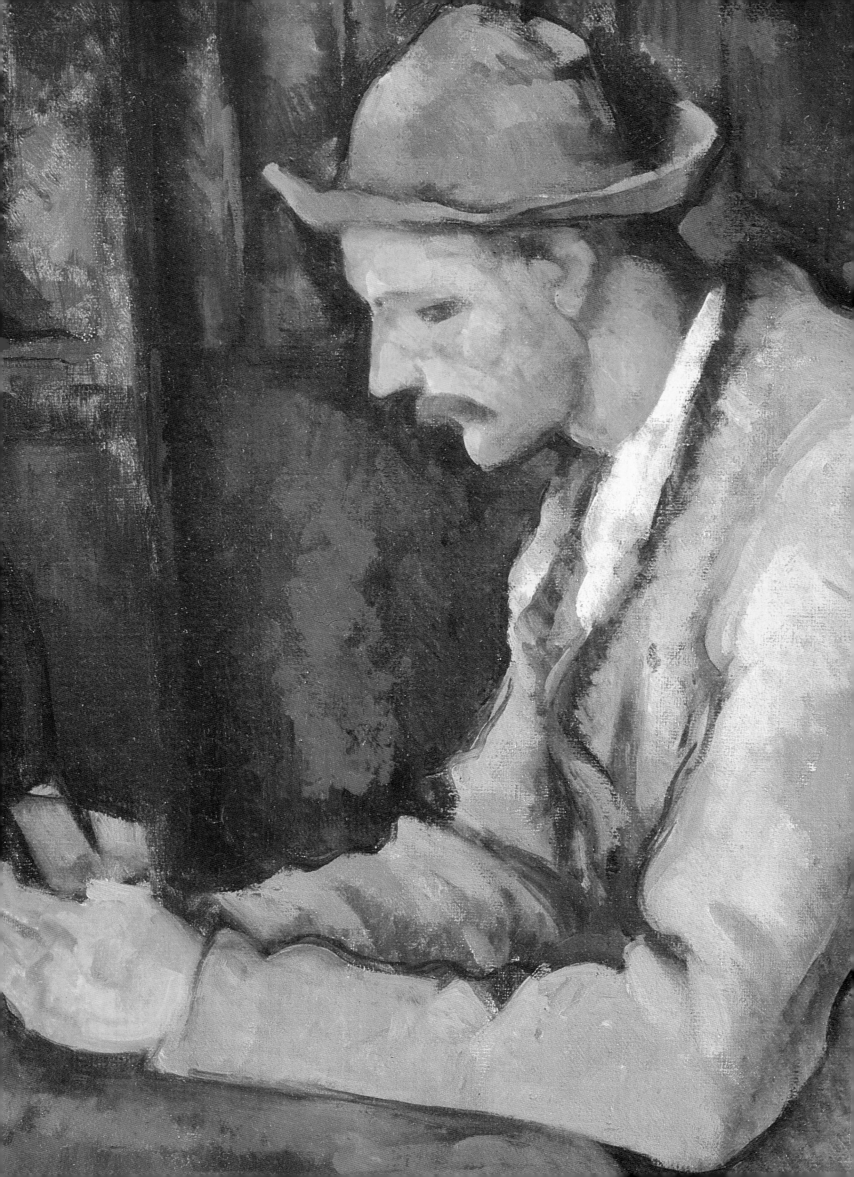

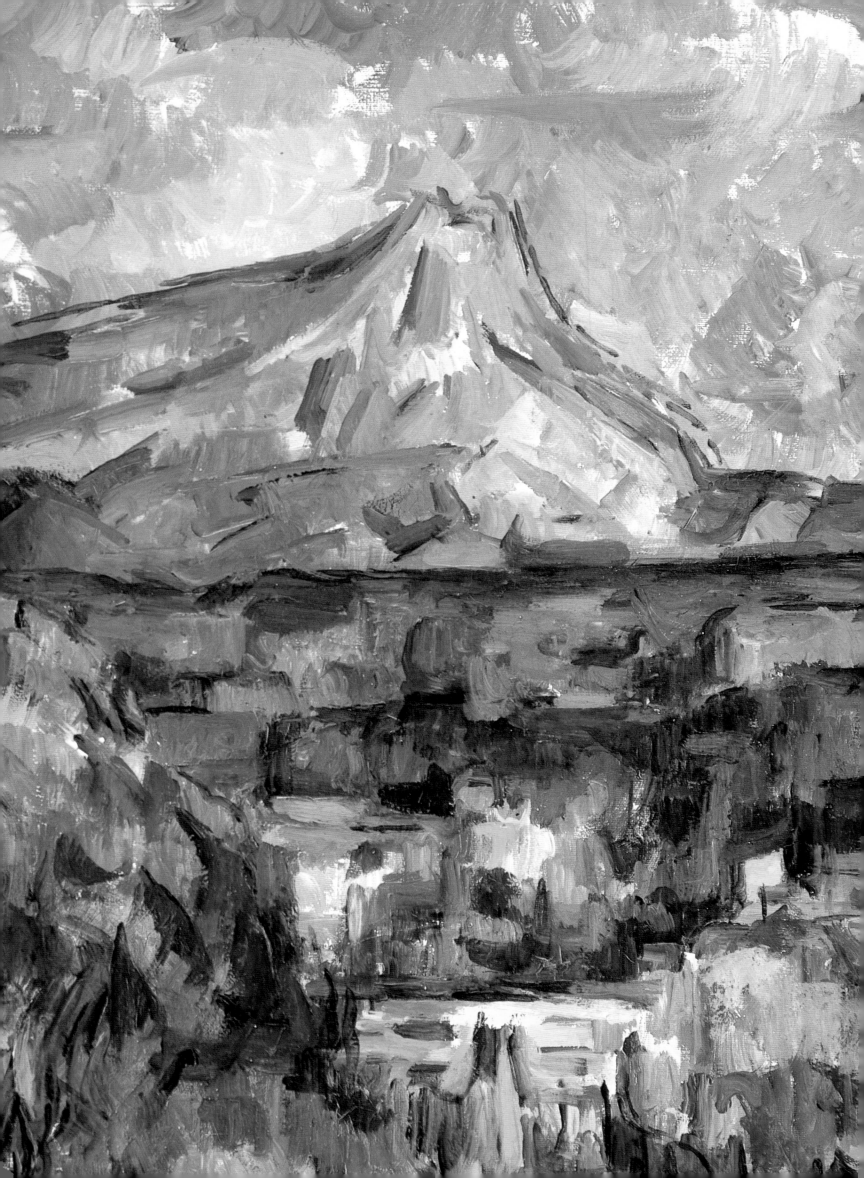

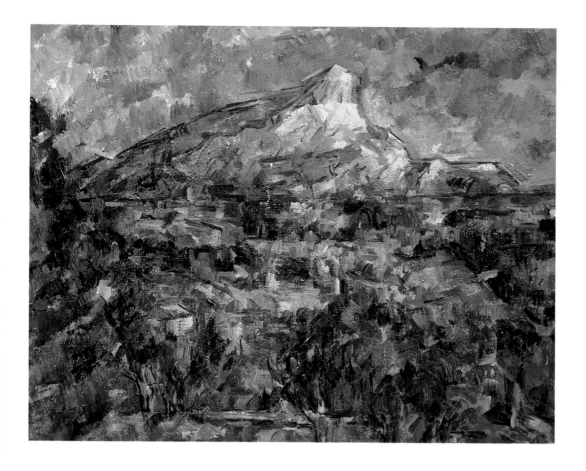

Landscape at Aix, La Montagne Sainte-Victoire
c. 1906; *oil on canvas*;
23 5/8 x 28 3/4 in. (60 x 73 cm.).
Moscow, Pushkin Museum
of Fine Arts.
This is one of the late views of the Montagne Sainte-Victoire seen from Cézanne's studio at Les Lauves. Joachim Gasquet, a poet and close friend of the artist during his final decade, reports a conversation with Cézanne in which the artist said: "Art is a harmony parallel to nature. . . . He [the painter] must stifle in himself the voices of prejudice, he must forget, always forget, establish silence, be a perfect echo. Then the landscape will inscribe itself on his sensitive tablet."

Mont Sainte-Victoire

The most conspicuous landmark of the region, Mont Sainte-Victoire had been well known in local history and legend since Roman times. Its impressive peak had stimulated earlier artists, whose works are largely forgotten today, with the exception of François-Marius Granet (1775–1849), an artist from Aix that Cézanne is known to have admired. But it was Cézanne who ultimately transformed the motif into the visionary, transcendent image of a powerful symbol of nature. The Mont Sainte-Victoire had appeared in the background of early works such as *The Rape* (c. 1867), but it was not until the last years of his life that the artist singled out this majestic

La Montagne Sainte-Victoire seen from Les Lauves

1904–1906; detail. Kansas City, Missouri,
The Nelson Atkins Museum of Art.
The close-up image with its mosaic of color fields placed against one another at different angles makes this landscape appear almost like the work of an abstract artist of the twentieth century. Cézanne broke the surface down into numerous planes with which he carefully constructed the landscape. Seen from a distance they convey an impression of vast spaces.

motif, turning it into something of a secular emblem of his deepened personal beliefs. The longer Cézanne worked on this series, the more spiritual in content the paintings became. When he moved into his new studio at Les Lauves in September 1902, he could see daily the mountain peak across the plane of the Arc River.

When compared to actual photographs taken from the same sites, Cézanne's paintings appear highly abstract. Subjective transformations have taken place to accommodate the painter's vision. Although the paintings appear clearly three-dimensional, the all-over patchwork of flat color planes produces a pronounced two-dimensionality. Furthermore, Cézanne often eliminated certain details in favor of a greater intensity in the mountain's appearance. He rarely changed the spot on the crest of the Lauves hill from which he frequently painted the Mont Sainte-Victoire during his last years, but he always slightly altered the angle from which he looked at it, thereby avoiding any sense of monotony. At times he added trees or buildings to the views. Another favorite spot was a location above the Tholonet Road, situated further to the east. "The principal thing in a painting is to find the distance," Cézanne told the German collector Karl Ernst Osthaus, who visited the artist in April 1906. And though it might apply just as well to many of his works, his remark is most fitting in regard to his depictions of the Mont Sainte-Victoire.

The Bathers

One of Cézanne's last major subjects was that of bathers in a landscape. Throughout his career, the artist aspired to portray human figures in nature similar to those he admired in the art of the great Venetian masters Giorgione and Titian, as well as in the work of Rubens and Watteau. The only Impressionist colleague who shared this interest with him was Pierre-Auguste Renoir; others either avoided human figures altogether or depicted them in modern urban or rural settings. Cézanne envisaged figures whose outdoor activity is devoid of almost any content. His very latest works are in fact only nominally bathers. One can follow the development of this theme from the earliest depictions with just a few figures to the late paintings which include up to fourteen bathers.

In the earliest depictions, such as *Bathers at Rest* of 1875–1876, the subject matter was, however, still explicit. The theme developed out of childhood mem-

ories of hiking and swimming with his friends Zola and Baptistin Baille in the countryside around Aix. In his novel, *L'Oeuvre* Zola recalled how the boys would "spend whole days there, stark naked, drying themselves on the burning sand, and then replunging into the river, living there as it were."

The bather paintings are segregated into groups of female and male bathers, which also recalls the experiences of his youth, but which is as well an expression of his continued difficulty in relating to the opposite sex. Compositionally, the male-figure groups form a friezelike pattern, open at the ends and extending occasionally farther into depth. They enjoy a greater freedom than their female counterparts and display more vigorous poses and greater energetic activity, something Cézanne associated with this subject from the beginning.

For more than a decade Cézanne explored this subject in numerous oil paintings and watercolors. *Ten Bathers* (c. 1894) is an extraordinary achievement, with its various robust colors, as is *Bathers* (c. 1899–1904), which consists almost exclusively of a large variety of blues. His efforts resulted in three monumental canvases with female bathers: *Nudes in a Landscape*, and two works titled *The Large Bathers*. Their chronological sequence is not certain since Cézanne worked on them intermittently over a long period of time (in fact, the final decade of his life), but for stylistic and compositional reasons it appears most likely that *Nudes in a Landscape* was begun first, followed by the version of *The Large Bathers* which resides in London, and finally the second *The Large Bathers*, now in Philadelphia. Roughly speaking, the female bathers form triangular groups, framed at the sides by inward-slanting trees, resulting in a closed, compact design. This feature is particularly evident in the version housed in Philadelphia, which for all its emotional aloofness is a highly personal image, whose sources lie deep within Cézanne's art and experience.

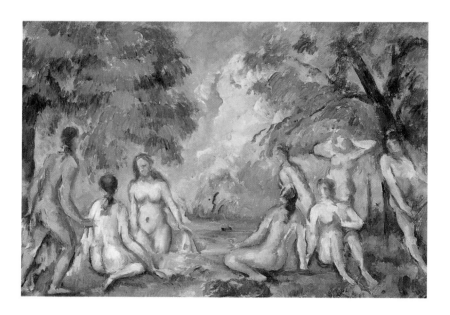

Eight Female Bathers

1895–1896; *oil on canvas;* 11 x 17 1/3 in. (28 x 44 cm.).
Aix-en-Provence, Musée Granet
(on deposit from the Musée d'Orsay, Paris).
Two figure groups of female bathers are arranged in separate pyramidal structures, linked by the presence of a dog at the center of the composition. This canvas was further developed in Nudes in a Landscape (Les grandes baigneuses), *where the bathers pose in a more stylized form. The back of the frame bears Cézanne's only dedication, that to Marie Gasquet, wife of the poet from Aix Joachim Gasquet, whom the painter met early in 1896.*

The Large Bathers

1902–1906; detail. London, National Gallery.
The artist's lifelong preoccupation with compositions of nudes in the open air resulted in a series of ambitious canvases painted during the last years of his life. In Cézanne's work the figures are subordinated to the demands of the composition. The standing figure on the left, for example, follows the line of the inward-leaning tree behind her.

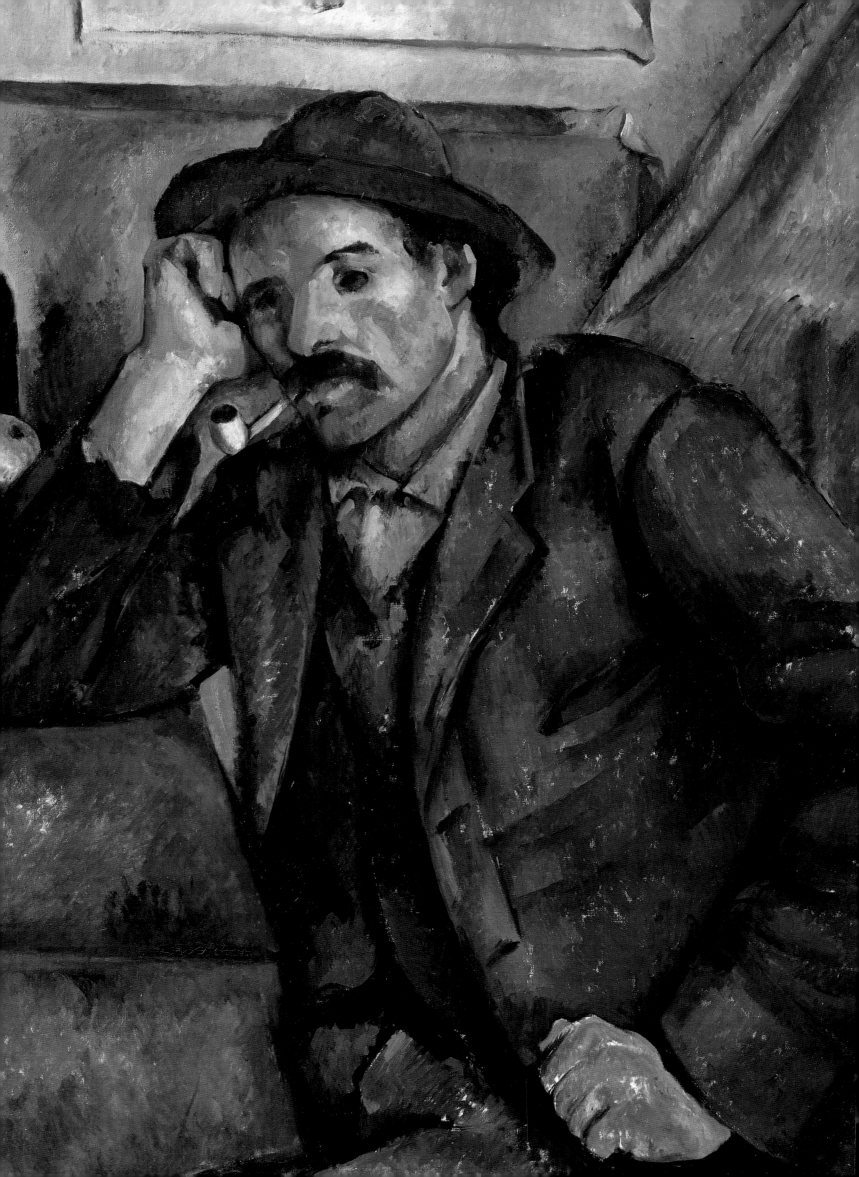

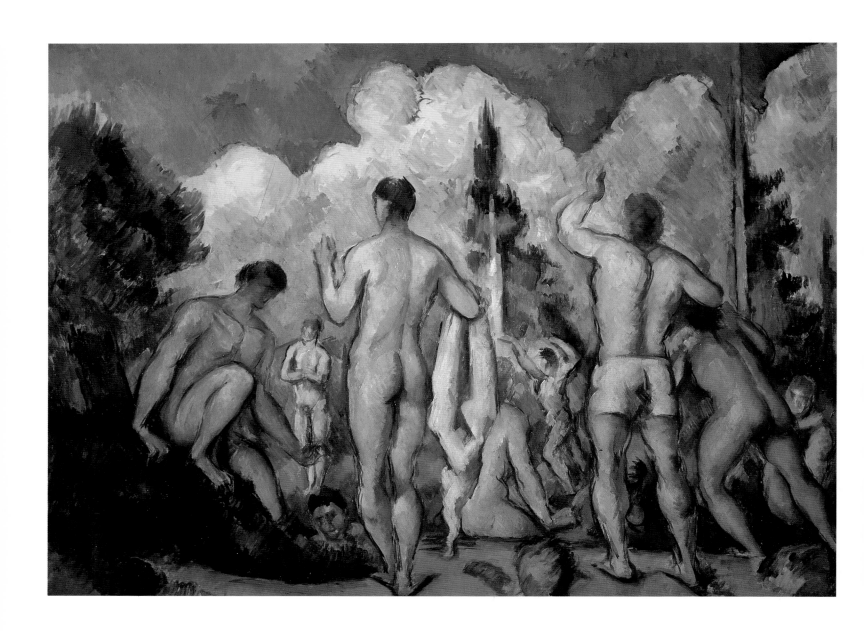

Ten Bathers

c. 1894; *oil on canvas*; 23 5/8 x 31 7/8 in. (60 x 81 cm.). Paris, Musée d'Orsay.

*In the early 1890s, the motif of male bathers was developed from earlier pictures by
enlarging the number of figures to nine and even ten bathers. Seen in various poses
and sizes, they appear at different distances from the viewer, fitted into an intricate
surface pattern. Larger than any previous version, the present painting is also more
robust in its coloring, with a warm yellow and tan tone of bathers vibrating against the
yellow-green foliage and orange-red earth, while a white cloud behind them, enlivened
with touches of the other colors present in the painting, is set against a deep-blue sky.*

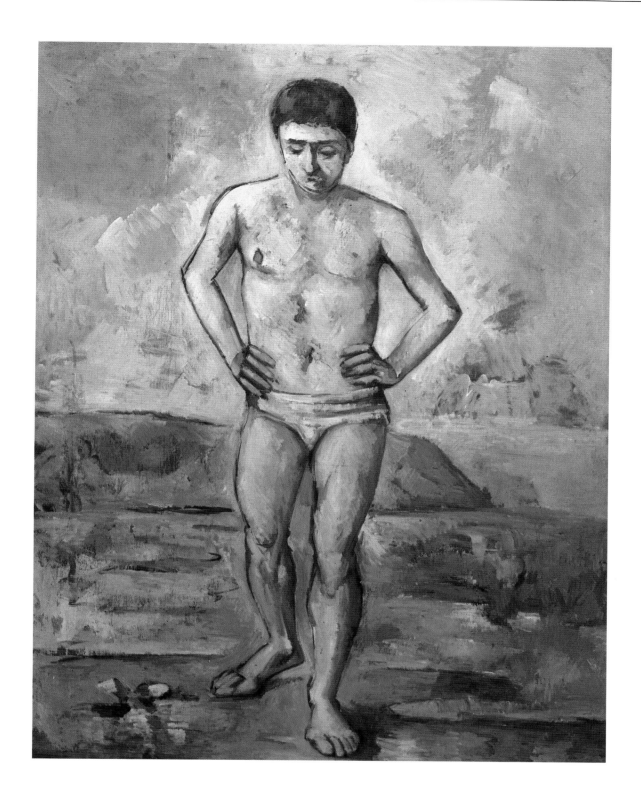

The Bather

c. 1885; *oil on canvas*; 50 x 38 1/8 in. (127 x 96.8 cm.).
Museum of Modern Art, New York.

*In a group of canvases Cézanne studied motifs of single bathers in preparation
for his large-scale compositions. The present figure was painted after a photo-
graph of a model. An almost identical pose of a male bather with arms akimbo
appears in the earlier* Bathers at Rest, *and in the lithograph of* The Large
Bathers. *The youthful body of the bather must have evoked memories of the
days when Cézanne went bathing with his friends in the Arc River in Aix.*

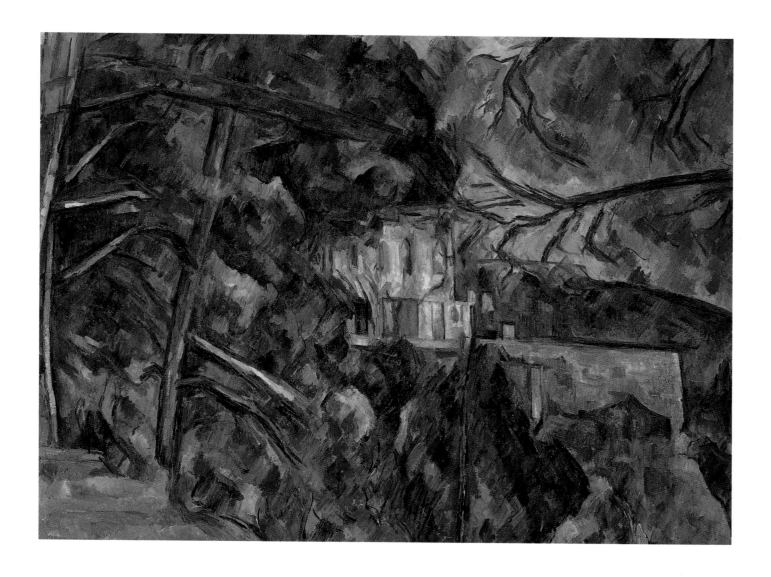

Le Château Noir
1900–1904; *oil on canvas*; 29 x 38 in. (73.7 x 96.6 cm.).
Washington, D.C., National Gallery of Art.
*The Château Noir is situated east of Aix in the
direction of Mont Sainte-Victoire. In Cézanne's time it
stood uninhabited most of the year. At the left appears
the path, strewn with pine needles, which leads to the
building from the Maison Maria. The pseudo-Gothic
windows reflect the blue sky, thus making the building
appear almost like a ruin. The house and its terrace
emerge with their ocher tones from the surrounding
deep blue and green like a ghostly vision. The name
Château Noir (Black Castle) is a misnomer and is
based on the local legends that surrounded its first owner.*

Rocks near the Caves above Château Noir
c. 1904; *oil on canvas*; 25 5/8 x 21 1/4 in. (65 x 54 cm.).
Paris, Musée d'Orsay.
*A dense, complex interplay of tree trunks, foliage, and
rocks characterizes this work, for which Cézanne used
a limited range of colors: orange for the rocks, various
shades of green for the vegetation, and deep, translucent
blue for the sky. The location appears to be near the
Château Noir, which Cézanne painted in a number of
views. This painting was formerly owned by Henri Matisse.*

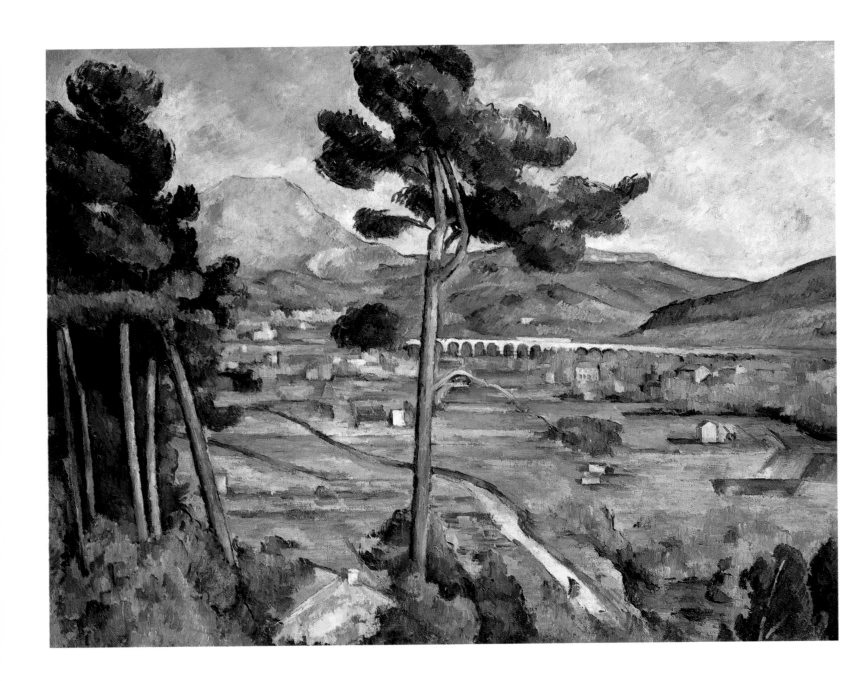

Mont Sainte-Victoire
c. 1885–1887; *oil on canvas;* 25 3/4 x 32 1/8 in. (65.5 x 81.7 cm.).
New York, Metropolitan Museum of Art, Havemeyer Collection.
Often Cézanne banned any modern aspects from his canvases, especially in
his landscapes, but here he included the railway bridge spanning the Arc
river valley, albeit without the puffing smoke from a passing train.
The pine tree at the center of the composition links the foreground with the
range of the Mont Sainte-Victoire massif in the distance. A green patch of
foliage to the left of the tree is linked to the trunk by an arch of the viaduct.

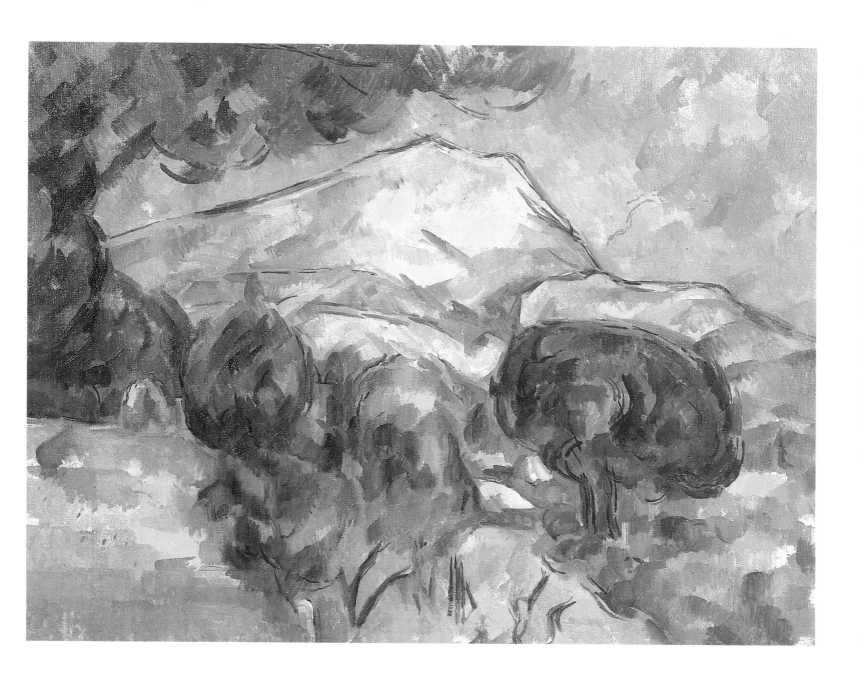

Mont Sainte-Victoire above the Road to Tholonet
c. 1904; *oil on canvas;* 28 7/8 x 36 1/4 in. (73.2 x 92.1 cm.).
Cleveland, Ohio, Cleveland Museum of Art.
Compared to earlier renderings of the subject, such as Mont Sainte-Victoire above
the Tholonet Road *(in the Hermitage), this painting is far more rhythmic and
synthesized in form, although it is seen from nearly the same position. The trees
have been flattened and are more formalized; the mountain itself appears more
abstracted. There is a strong pull or tension between the trees on the lower right
and the rounded forms of the trees along the bordering frame on the upper left.*

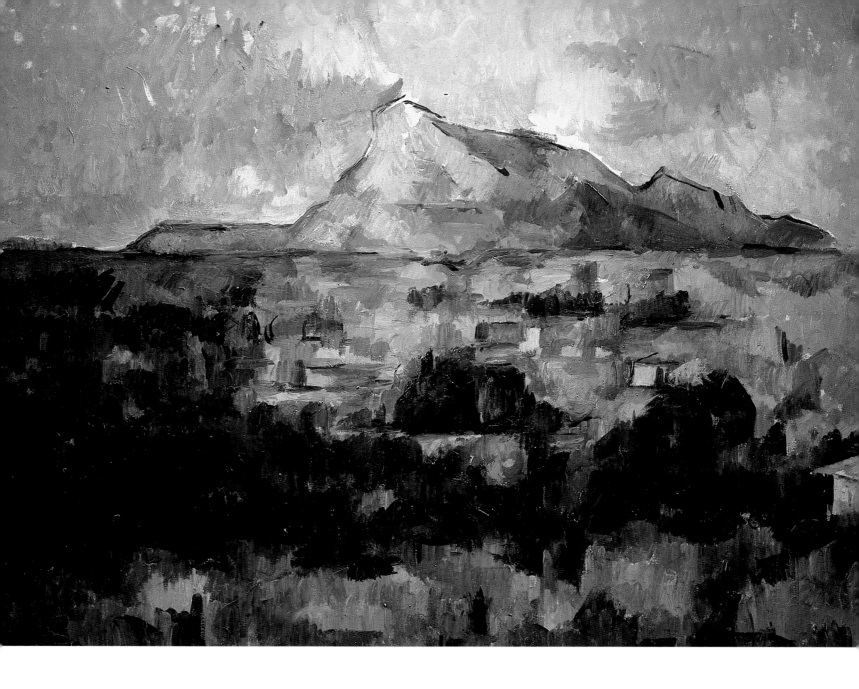

Mont Sainte-Victoire
1904–1906; *oil on canvas;* 26 x 32 1/8 in. (66 x 81.5 cm.).
Zurich, Private Collection.
From the studio on the hill known as Les Lauves the peak of Mont Sainte-Victoire appears with its rising back ending abruptly at a steep cliff, from where it tapers off toward the lower Mont du Cengle. The horizontal lines provide a sense of breadth, as Cézanne himself noted, while the perpendiculars give depth. The insistence on the same motif with its rise from the dark valley toward a luminous sky should perhaps be seen in the context of the artist's deep religious feelings, which he often attached to his paintings.

Mont Sainte-Victoire seen from Les Lauves
1904–1906; *oil on canvas;* 25 5/8 x 32 in. (65 x 81.3 cm.).
Kansas City, Missouri, The Nelson Atkins Museum of Art.
Cézanne never denied the two-dimensionality of the canvas. He achieved space and depth through an interdependent network of color patches, here mostly of rectangular forms. The various relationships of these color fields define and model the objects recognizable to the experienced human eye. Abandoning the rules of Renaissance perspective, Cézanne ushered in the modern art of the twentieth century, although he himself would certainly have disapproved of many of its developments.

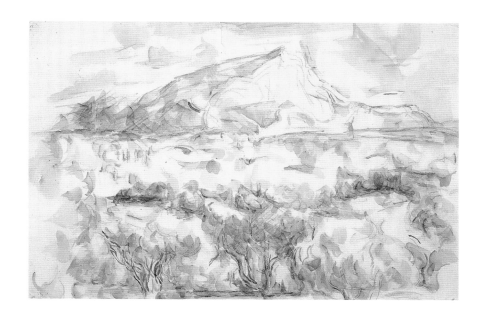

La Montagne Sainte-Victoire
1905–1906; *watercolor on paper;*
14 1/4 x 21 5/8 in. (36.2 x 54.9 cm.).
London, The Tate Gallery.
The painter Emile Bernard, who visited Cézanne in February–March 1904 in Aix, described his older colleague's methods while working with watercolors: "His method was strange, entirely different from the usual practices and of an extreme complexity. He began with the shadows and with a touch, which he covered with a second more extensive touch, then with a third, until all these tints, forming a mesh, both colored and modeled the object."

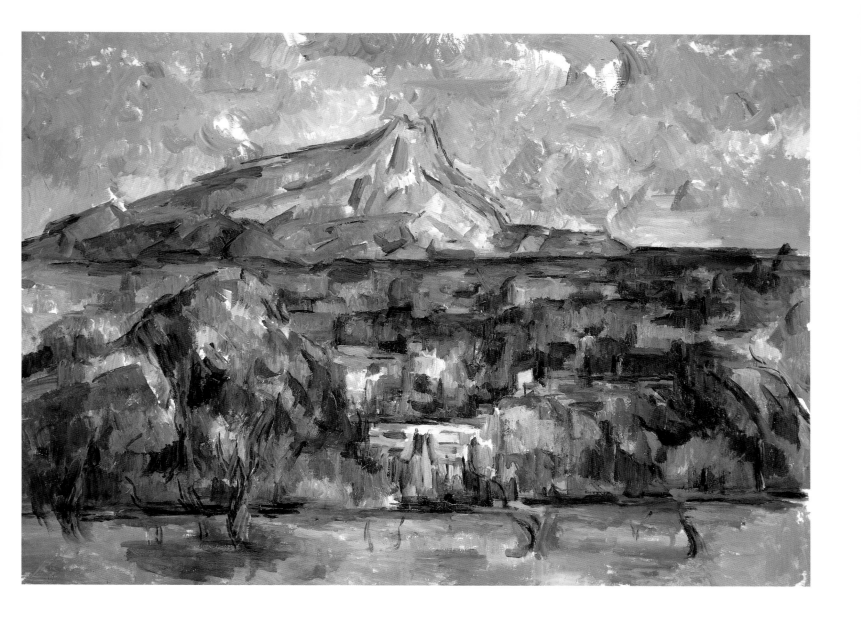

Boat with Bathers

1890–1894; *oil on canvas*; 11 3/4 x 49 1/4 in. (30 x 125 cm.).
Paris, Musée de l'Orangerie.
This is one of the few works by Cézanne designed for
a specific architectural setting. It was intended as an
overdoor for the Paris apartment of collector Victor
Chocquet, who over the years purchased more than thirty
of the artist's works. The peculiar subject perhaps repre-
sents an allegory of earth and water. With the exception
of his views of L'Estaque, this is Cézanne's only seascape.

Nudes in a Landscape

1900–1905; *oil on canvas*; 32 1/8 x 39 7/8 in. (82 x 101.2 cm.).
Merion, Pennsylvania, The Barnes Foundation.
The theme of nude bathers in a landscape occupied
Cézanne during the last two decades of his life. Here,
a number of female nudes are arranged in various poses
of animation and leisure in a sheltered glade. A picnic-
like still-life in the foreground, including a black dog,
adds a charmingly mundane element to the scene. The
figures are complexly modeled in a variety of flesh tones
which include brilliant reds, jade greens, and dark blues.

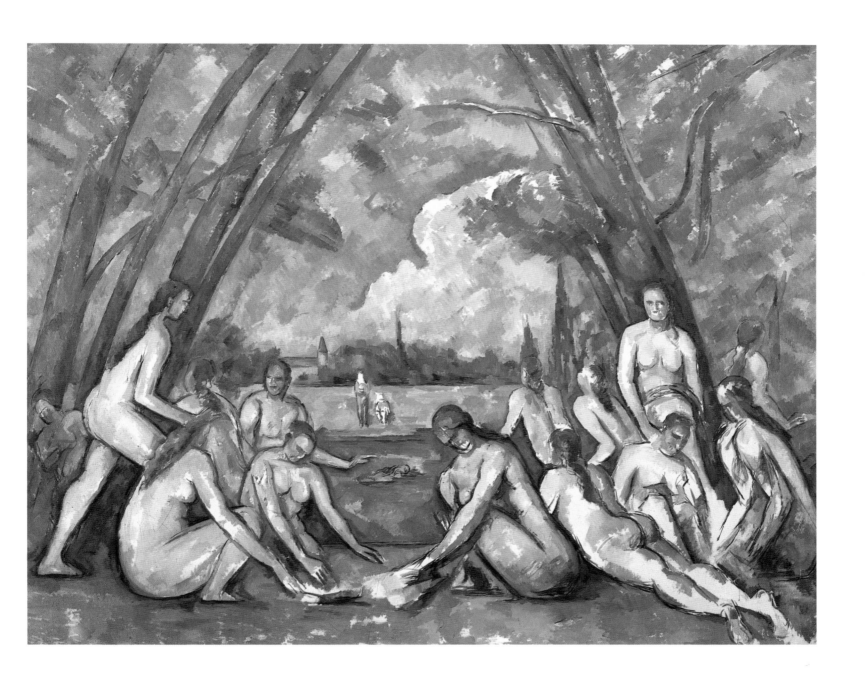

The Large Bathers

1899–1906; *oil on canvas*; 81 7/8 x 98 in. (208 x 249 cm.).

Philadelphia, Pennsylvania, Philadelphia Museum of Art, W. P. Wilstach Collection.

This is the largest version of Cézanne's many paintings and studies with bathers.
The colors are somewhat subdued, with a dominating yellowish brown against
a pale-blue sky. The trees bend from two sides toward the center of the composition
and form a protective arch reminiscent of the windows or vaults of Gothic churches.
As in the artist's other paintings of bathers the sexes are not mixed, the group
here consisting of around fourteen female figures. Although Cézanne worked
over a number of years on this composition, it was in fact never completed.

CREDITS

Albright-Knox Gallery, Buffaalo, NY; Fellows for Life Fund, 1927 p. 66

The Art Institute of Chicago, Chicago, IL, Mr. and Mrs. Martin A. Ryerson Collection, 1933.1116 p.70; Wilson L. Mead Fund, 1948.54 p.81; Amy McCormick Memorial Collection, 1942.457 p.138;

The Barnes Foundation, Merion, PA; photographs © 1992. All rights Reserved, pp. 94, 99 (top), 108, 121, 123, 125, 137 (bottom)

Bridgeman/Art Resource, New York p. 127

Bridgestone Museum of Art, Tokyo, Japan, Giraudon/Art Resource, New York p. 16 (top)

The Brooklyn Museum, Brooklyn, NY p. 73 (right)

E.G. Buehrle Collection, Zurich, Switzerland, Erich Lessing/Art Resource, New York pp. 11 (detail), 26 (detail), 33, 36, 91, 95

The Carnegie Museum of Art, Pittsburg, PA; Acquired through the generosity of the Sarah Mellon Scaife family, 66.4, p. 59

Cleveland Museum of Art, Cleveland, OH, Giraudon/Art Resource, New York p. 133

Columbus Museum of Art, Columbus, OH; Museum Purchase: Howald Fund, p. 93

Courtauld Institue Galleries, Courtauld Collection, London, England, pp.58 (detail), 77, 113, 125, 144

The Detroit Institute of Arts, Detroit, MI; Bequest of Robert H. Tannahill, p. 6

The Fitzwilliam Museum, Cambridge, England; By kind permission of the Provost and Scholars of King's College, Cambridge, pp. 23 (detail), 32

Folkwang Museum, Essen, Germany, Erich Lessing/Art Resource, New York pp. 12 (detail), 76

The J. Paul Getty Museum, Malibu, California pp. 22 (detail), 34, 82

Giraudon/Art Resource, New York; Collection Sam Spiegel, p. 55

Graphische Sammlung Albertina, Vienna, Austria, Erich Lessing/Art Resource, New York p. 16 (bottom)

Hermitage, St. Petersburg, Russia, Scala/Art Resource, New York pp. 10, 15, 24-25, 72-73, 78, 86, 101, 109, 120

The Israel Museum, Jerusalem, Israel pp. 7, Sam Spiegel Collection 20, 67 (top) photo: David Harris; 75

Kunstmuseum, Basel, Switzerland, Giraudon/Art Resource, New York pp. 116 (detail), 122

The Metropolitan Museum of Art, New York, NY, p. 41 (on loan); p. 132, Bequest of Mr. and Mrs. H.O. Havemeyer, 1929. The H.O. Havemeyer Collection; p. 47, Private Collection.

Montreal Museum of Fine Arts, Montreal, Canada, photo Brian Merrett p. 37

Musée de l 'Orangerie, Paris , France, Giraudon/Art Resource, New York pp. 51, 85, 136-137 (top)

Musée d'Orsay, Paris, France, Giraudon/Art Resource NY pp. 4, 5, 8-9 (detail), 19, 38, 44, 45, 46, 60, 62, 83, 98, 107; Erich Lessing/Art Resource, NY pp. 8-9 (detail), 29, 30, 32, 35, 40-41, 42, 64 (top and bottom), 69, 84 (detail), 87, 88-89, 100, 95, 102, 103, 104-105, 110, 115 (detail), 126, 128, 130 ; Bridgeman/Art Resource, NY p. 127

Musée Granet, Aix-en-Provence, France, on deposit from Musée d'Orsay, Paris, France, p. 118

Musée Picasso, Paris, France/Reunion des Musées Nationaux p. 68

Musée du Petit Palais, Paris, France/Art Resource, New York pp. 21, 80

Museu de Arte Assis Chateaubriand, Sao Paulo, Brazil, photo © Luiz Hossaka p. 28; Giraudon/Art Resource, New York p. 21

Museum of Fine Arts, Boston, MA, Bequest of John T. Spaulding, Courtesy of Museum of Fine Arts, Boston p.67 (bottom)

Museum of Fine Arts, Houston, TX, The Robert Lee Blaffer Memorial Collection, gift of Sarah Campbell Blaffer p. 92

Museum of Modern Art, New York, NY Lillie P. Bliss Collection. © The Museum of Modern Art, New York, 1994 p. 129

Národni Galeri, Prague, Czech Republic, Erich Lessing/Art Resource, New York p. 17

The National Gallery, London, England, Reproduced by courtesy of the Trustees pp. 65, 68; p. 71; Erich Lessing/Art Resource, New York pp. 54 (top), 119 (detail), 139

National Gallery of Art, Washington, D.C., Collection of Mr. and Mrs. Paul Mellon p. 31; Gift of Eugene and Agnes E. Meyer pp. 114 (detail), 131

National Gallery of Australia, Canberra, Australia p. 99 (bottom)

National Gallery of Canada, Ottawa, Canada p. 97

National Museum of Wales, Cardiff, Wales, Giraudon/Art Resource, New York p. 106

The Nelson Atkins Museum of Art, Kansas City, MO p. 135 (bottom)

Neue Pinakothek, Munich, Germany/Artothek pp. 35, 61

Philadelphia Museum of Art: Purchased: W.P. Wilstach Collection p.141

Private Collections: Giraudon/Art Resource, New York pp. 50, 140; Zurich, Switzerland, Erich Lessing/Art Resource, New York pp. 32 (detail) 111, 134

Pushkin Museum, Moscow, Russia, Scala/Art Resource, New York pp. 14, 18, 49, 52, 53, 54 (bottom), 56-57 (detail), 74, 79, 90, 112, 117, 124

Sam Spiegel Collection, New York, NY/Art Resource, New York p. 55

Staatliche Museen, Nationalgalerie, Berlin, Germany, Erich Lessing/Art Resource, New York pp. 43, 63

Staedtisches Kunstinstitut, Frankfurt am Main, Germany, photo: Ursula Edelmann p. 39

Staedtisches Museum, Mannheim, Germany, Erich Lessing/Art Resource, New York p. 13

The Tate Gallery, London, England/Art Resource, New York pp. 48, 96, 124 (top), 135 (top)

Walker Art Gallery, Liverpool, England; Courtesy Board of Trustees of the National Museums and Galleries on Merseyside p. 27